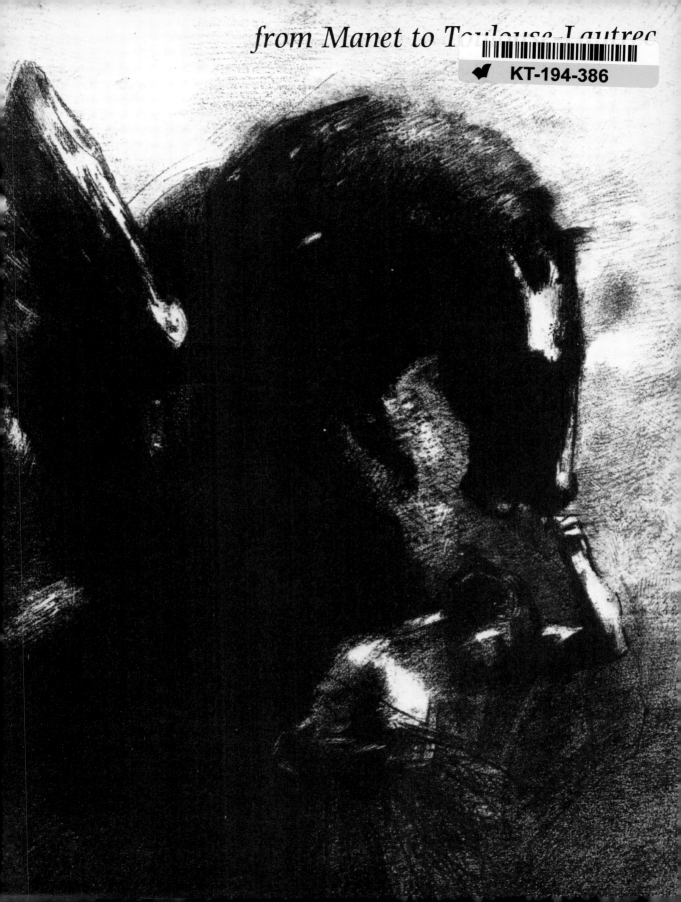

from Manet to Toulouse-Lautrec

from Manet to

Published for the Trustees of the British Museum by
BRITISH MUSEUM PUBLICATIONS LIMITED

Toulouse-Lautrec

FRENCH LITHOGRAPHS 1860–1900

Catalogue of an exhibition at the Department of Prints and Drawings in the British Museum, 1978
by Frances Carey and Antony Griffiths

Cover: Toulouse-Lautrec *May Belfort* (cat. 115)
Back cover: Redon *Araignée* (cat. 32)

© 1978 The Trustees of the British Museum

ISBN 0 7141 0763 8 (paper)
ISBN 0 7141 0764 6 (cased)

Published by British Museum Publications Ltd,
6 Bedford Square, London WC1B 3RA

Designed by Roger Davies

Set in Photina and printed in Great Britain by
Balding and Mansell Ltd, London and Wisbech

Contents

page 6 *Preface*

7 *Note on Campbell Dodgson*

11 *Introduction*

18 *Lithography: technique and printing*

 CATALOGUE:

23 Bresdin

28 Courbet

30 Millet

30 Corot

32 Manet

44 Redon

53 Pissarro

62 Degas

67 Gauguin

69 Puvis de Chavannes

69 Cézanne

71 Sisley

71 Renoir

71 Chéret

72 Toulouse-Lautrec

91 Bonnard

93 Vuillard

97 *Complete list of lithographs*

Preface

The main purpose of this exhibition is to publicize the almost unknown group of late nineteenth-century French prints which was bequeathed to the British Museum by Campbell Dodgson in 1948. The whole group is very large and we have had to confine our attention to the lithographs, which are unquestionably the most important part. For the same reason we have not attempted to give an historical survey of the period but have concentrated on the work by the most distinguished artists. This principle of selection has entailed the exclusion of artists like Fantin-Latour and Carrière, who enjoyed considerable contemporary acclaim for their mastery of lithographic techniques, but the introductory essays do attempt to provide an historical context and the necessary background information. The Museum's entire holdings of lithographs by the artists included in this exhibition have been summarized in checklists appended to the main body of the catalogue in order to increase its usefulness as an introduction to the collection.

Our work has been greatly assisted by a number of people. James Byam Shaw answered questions about Dodgson and most generously presented to the Department all Dodgson's surviving papers and letters. Jane de Teliga, now at the Art Gallery of New South Wales, devoted part of a year's scholarship in the Print Room to compiling the bibliographical information for many of the items in the exhibition. Stanley Jones of the Curwen Press kindly elucidated the technical problems posed by some of the lithographs. Juliet Wilson most generously read the entries on Manet which are greatly indebted both to her information and to her criticism; the exhibition with its exemplary catalogue which she arranged in 1977 at Ingelheim-am-Rhein considerably advances our knowledge about Manet's prints. We also owe thanks for various courtesies to E. W. Kornfeld of Bern and Lawrence Smith of the Department of Oriental Antiquities.

Campbell Dodgson 1867–1948

Almost every item in this exhibition was either presented or bequeathed to the Department by Campbell Dodgson, its former keeper. Born in 1867 he was educated at Winchester and New College, Oxford, where he was awarded a first in classics. He then read theology for a year intending to enter the Church, but changed his mind and joined the staff of the British Museum in 1893. It seems fairly clear that he had shown no pronounced interest in art before this date, and henceforth he channelled his interests in the directions he felt most appropriate for the Department's needs. In 1895 the task fell to him of cataloguing the superb gift of early German woodcuts made by William Mitchell, and in the ensuing years he made himself an authority of world renown on the subject. In 1912 he succeeded Sir Sidney Colvin as Keeper of the Department and remained in this position until his retirement in 1932.

At his death in 1948 Dodgson bequeathed to the Museum his entire collection of prints and a few drawings, which amounted to well over 5,000 items and constitutes the most important gift of its kind made to the Department this century. Its peculiarities as a collection are explained by the fact that it was, from the outset, conceived as a complement to the existing holdings of the Department. Dodgson never duplicated prints already owned by the Museum, and concentrated his purchases where the collection was weakest; thus almost all were of modern prints by contemporary artists. Conversely he never, as Keeper, bought for the Department the material he was collecting. The Contemporary Art Society, of which Dodgson was a founder member, presented work to the Department, as did a number of artists, but he appears to have had inhibitions about spending Government money on contemporary art. The bequest consists of about 2,500 English prints (including very large groups of work by D. Y. Cameron, Augustus John, Muirhead Bone and William Strang), approximately 1,500 French prints (with a strong representation of Forain, Laboureur and Segonzac) and about 1,000 prints from other schools. Catholic though Dodgson's taste was, it was not all-embracing. His loyalties lay with the craftsmen 'peintres-graveurs', most of whom, at least in the case of the British printmakers, are now almost totally ignored. He was unsympathetic to the avant-garde trends of the early twentieth century; for example, he bought Picasso's pre-Cubist prints, but none from his later periods with the significant exceptions of two works from his neo-classical phase of the 1920s and three plates from Buffon's *Histoire Naturelle*. He professed a deep antipathy towards the German Expressionists, although he did acquire numerous works by Liebermann, Corinth and the traditional artists of later years.

The group of works by French artists of the later nineteenth century, from which this exhibition is drawn, is perfectly consistent with Dodgson's taste for the 'peintres-graveurs' and the scope of the whole

collection. The interesting question, but one which is difficult to answer, is what relative importance Dodgson himself would have assigned to this particular group of prints within the context of his collection as a whole. Strangely, although he wrote voluminously on early German woodcuts and contemporary artists, Dodgson seems hardly ever to have discussed these prints. In an essay entitled *The Classics*, published in 1938 by Knoedler (reprinted in *Print Collectors' Quarterly*, XXVI, 1939, pp. 161ff.), he made a sort of profession of faith and singled out as the greatest nineteenth-century printmakers Meryon, Whistler, Menzel, Daumier, Gavarni, Legros, Manet, Lautrec, Redon, Forain and Zorn. Much more important is the catalogue of an exhibition he held in his own home at 22, Montagu Square in 1919 of *Etchings and Lithographs by Modern French Artists*, drawn entirely from his own collection. The proceeds were to go to the 'Contemporary Art Society's fund for the purchase of modern prints and drawings for the British Museum'. The lithographs exhibited were by Redon, Manet, Corot, Pissarro, Lautrec, Carrière and Fantin-Latour, with a large group by Forain for whom Dodgson shared Degas' admiration. From the biographical comments he made on the various artists, it is obvious that he already had a clear appreciation of Manet's importance and a special enthusiasm for Redon. The exhibition in 1919 proves that Dodgson then possessed a very fine collection of these prints; at a time when few people in England paid serious attention to modern French art this taste was precocious. Douglas Cooper, in his catalogue of the Courtauld Collection has traced the lamentable history of English indifference to the Impressionists; Dodgson's name deserves to be added to the list of pioneers.

The preface to the 1919 catalogue explains the limitations of the exhibition: 'This little exhibition itself may very likely be taxed with timidity and conservatism. It is certainly not ultra-modern. . . Where are *les Jeunes*, *les Fauves*, the Cubists and Expressionists. . .? In an ideal exhibition of modern French art they should undoubtedly make a display, but for that the time is not yet fully ripe. They are excluded now, not from prejudice, but from lack of space and lack of material to represent them properly.' He continues the preface to express the hope that in future years the lacunae may be filled and an English equivalent established to the Doucet collection at the Bibliothèque d'Art et d'Archéologie in Paris.

This hope was not to be realized. Dodgson continued buying avidly until his death in 1948, and in this time added many of the greatest rarities to the collection including Manet's *Ballon* and Degas' *Baigneuses*. The Toulouse-Lautrecs were largely acquired after 1925 and the works by Bonnard and Vuillard in the 1930s, when the Leicester and Redfern Galleries arranged a series of exhibitions devoted to the French lithographs of the 1890s. Dodgson never however

conquered his aversion from *les Jeunes*, the Cubists or the Expressionists; and since the Museum's collection of modern prints has scarcely advanced since the assimilation of the Dodgson bequest, it remains almost totally deficient in these areas. The present policy of the Department is not to continue the collection of prints after 1945. This at least defines and limits the deficiency and offers hope that in the forthcoming years a representative collection may be put together.

These constraints do not in any way detract from the stature of Dodgson's achievement. From his earliest days in the Museum he had been concerned mainly with prints, and there was little he did not know about them. He had the true print connoisseur's love of a rarity or early state, and the impressions that he acquired were invariably of high quality. The group of late nineteenth-century French prints shown here only in part is unquestionably the best ever assembled in Britain, and remains one of the best in Europe outside Paris itself. Nonetheless the collection is almost unknown both to scholars and to the general public. Dodgson lent some items to a travelling Arts Council exhibition in 1947; but the exhibition held on the centenary of Dodgson's birth in 1967–8 could perforce only allot a small space to this fragment of the whole collection. The present exhibition and the catalogue are intended to redress the balance.

NOTE: There is an excellent obituary of Dodgson by A. E. Popham in the *Proceedings of the British Academy*, XXXVI, 1950; J. Byam Shaw's reminiscences of him are published in *JBS – Selected Writings*, 1968. Dodgson's papers which Mr Byam Shaw has kindly presented to the Department unfortunately tell little about this part of his collection. They comprise two files of personal and scholarly correspondence, about forty books of notes taken in the print rooms of Germany, a file of letters with various French artists of 1919, and finally a large bound volume filled with the cuttings of Dodgson's occasional writings. The Department possesses in addition a card index which gives the provenance and the price paid for a disappointingly small proportion – about one twentieth – of his collection. The provenances given in this catalogue which have no other reference are taken from this.

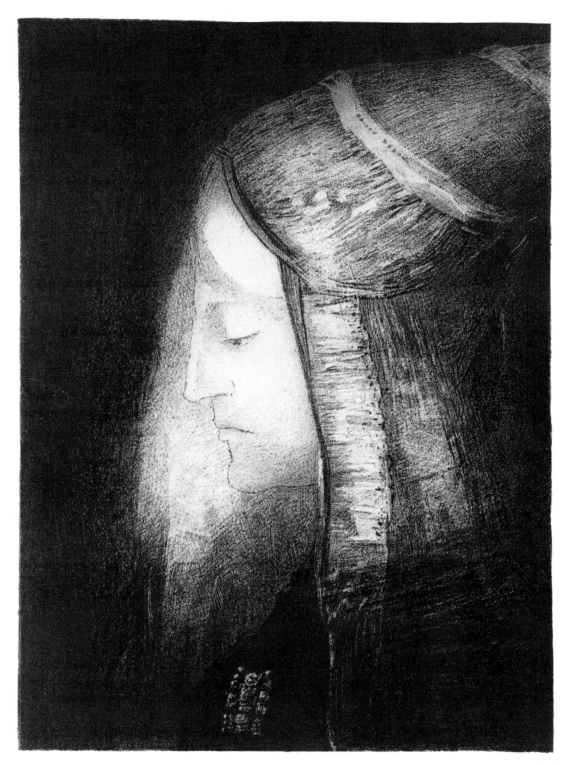

Introduction

The Early Years

Lithography was invented in 1798 by Alois Senefelder in Munich. It was the first entirely new printing process to be discovered since the fifteenth century. It offered enormous scope for commercial as well as artistic production and one might have expected that its impact would be immediate and profound. But strangely this was delayed for some twenty years, partly through Senefelder's lack of business flair and perhaps more through the numerous initial technical difficulties which had to be surmounted. Senefelder was however well aware of the potentialities of his process in the artistic field and formed various partnerships to operate lithograph presses in the capitals of Europe; one of the most enterprising was his London agent Philipp André and his successor G. J. Vollweiler who issued the *Specimens of Polyautography*, containing original lithographs by many of the leading British artists, between 1803 and 1807, when the enterprise collapsed. In Germany the lithograph had a less spectacular but more certain development, but France lagged well behind.[1] Although presses were set up in Paris by 1802, nothing significant was produced until in 1816 Godefroy Engelmann moved his press from Mulhouse to Paris. Within a few years lithography had become enormously fashionable among the leading French artists and the 1820s saw the creation of some of the greatest masterpieces of the medium. Géricault made nearly a hundred lithographs between 1818 and his early death in 1823, while Delacroix made most of his finest prints in these years. Other artists of the period whose work was then famous but is now unjustly neglected were the lithographers of military, usually Napoleonic, subjects like Carle and Horace Vernet and Charlet.

The new Romantic generation of the 1830s brought with it a preoccupation with landscape. The origins of this fashion go back to the previous decade, to the work of Bonington (who died in 1828) and the enormous publication by Baron Taylor, the *Voyages Pittoresques et Romantiques dans l'ancienne France*, begun in 1820 and not abandoned until 1878. The abundant production catalogued by Adhémar continued well in the 1850s but with diminishing vigour – Adhémar's list breaks off at 1854.[2]

The decline of landscape lithography in the 1850s was paralleled in the other genres. Raffet, the last practitioner of Napoleonic genre died in 1860. Even the vigorous tradition of political and social satire begun by Daumier in the 1830s and taken up by Gavarni and a host of imitators had already seen its best days; Daumier was nearly blind from 1870, and the astounding events of the siege of Paris and the Commune found no worthy commentators. In the case of satire there was the further handicap of the critics' prejudice against an inferior genre; Daumier was not widely accepted as a great artist before this century. One final

1. The early history of lithography has been exhaustively studied by M. Twyman: *Lithography 1800–1850*, London, 1970.
2. J. Adhémar: 'Les lithographies de paysage en France à l'époque romantique', *Archives de l'Art Francais*, XIX, 1938, pp. 189–364.

class which ought to be noticed is the reproductive lithograph after an oil painting. This type had its origins in the 1820s as a rival to the reproductive engraving, and shared in the official critical esteem then accorded to the reproductive print. The lithography section in the annual Salon was full of productions of this type by Celestin Nanteuil, Achille Sirouy and a host of other now forgotten artists. But although many of these lithographs are still very impressive *tours de force*, their future was closed almost from the beginning by the invention of photography.

The decline of the lithograph was noticed and deplored by contemporaries. Philippe Burty, perhaps the most important collector, critic and *marchand-amateur* of prints, reviewed the lithography section of the Salon of 1861 in the *Gazette des Beaux-Arts* and announced: '*La lithographie se meurt par l'oubli des grands principes qui doivent présider à toute oeuvre d'art. Les peintres seuls pourraient lui rendre la vie*'.[3] He then proceeded to attack the reproductive print in favour of the original creation. Now in this plea Burty was not acting in an entirely disinterested fashion. These same years saw the beginning of the so-called 'etching revival'; like the lithograph (but to not nearly so marked a degree) the etching had been declining in esteem, but now the vigorous propagandizing of Burty, Bracquemond and others, building on the remarkable achievements of Charles Méryon, led to the founding of the *Société des Aquafortistes* in 1862. It found a printer in Delâtre and an enterprising publisher in Cadart. In September 1862 the first *livraison* was published by the *Société*, with five etchings by Bracquemond, Daubigny, Legros, Manet and Ribot.[4]

The time must have seemed ripe to attempt a similar revival for lithography. What followed is reported by Hédiard in his catalogue of Fantin-Latour's lithographs:

Un fait moins connu, c'est que l'eau-forte n'avait pas été seule à tenter ces chercheurs d'Amériques [viz. the members of the *Société*]. *La lithographie leur avait aussi paru bonne à donner du nouveau, pourvu qu'on prît la peine de lui en demander. Précédemment, M. Bracquemond avait lithographié beaucoup et selon toutes les formules en usage. Un jour, Cadart lui envoya trois pierres et Manet, Ribot, M. Legros, M. Fantin en reçurent autant chacun, avec instructions de dessiner dessus absolument ce qu'ils voudraient. Le tout devait former ensuite un cahier qu'on publierait. Les uns et les autres se mirent à l'ouvrage. Manet fit 'le Ballon'; Ribot, 'la Lecture'; M. Legros, 'les Carriers de Montrouge'; M. Bracquemond, 'les Cavaliers'. M. Fantin, qui prenait pour la première fois le crayon lithographique, se montra le plus acharné; il couvrit les trois pierres; il fit même, sur l'une d'elles, deux dessins au lieu d'un. Quand elles revinrent chez Lemercier, ce fut un cri: c'était détestable, insensé, sauvage, on n'avait jamais vu chose pareille, on n'oserait pas mettre cela sous la presse! On s'y décida, néanmoins, par curiosité, et de*

3. *Gazette des Beaux-Arts*, XI, 1861, p. 177.
4. J. Bailly-Herzberg: *La Société des Aquafortistes*, two vols, Paris, 1972.

chacune des pierres, avant de les effacer, on tira pour les camarades, sans y mettre aucun soin, cinq ou six épreuves aussitôt distribuées. [5]

One extraordinary feature of this episode is that Hédiard's is the only information which seems to be available about it; had Hédiard not written we would have no idea that it had happened. But there is no reason for doubt; the rarity of the prints supports him, and proves the total failure of Cadart's attempt to revive the lithograph. [6] In later years Cadart restricted his energies to fostering and supplying the rapidly expanding market for original etchings; the catalogue of his stock published in 1876 by his widow shows that it included no lithographs. [7]

For the following two decades artistic lithography in France does not really have a history; there is only a chronicle of sporadic manufacture of lithographs. The earliest print in this exhibition is by Courbet and was made in 1850 as Fourierist propaganda. Millet's piece of 1851 was a commission from an artistic journal. Corot, a generation older than Millet, made a few lithographs in 1871–4, the last years of his life, only at the urgings of his friends. Rodolphe Bresdin was a freakish eccentric whose extraordinary works fit into no pattern at all.

The first serious interest and real commitment to lithography we find with Edouard Manet. When Cadart sent him the stone in 1862 he had only previously made one caricature in the medium; but the experience of making *Le Ballon* seems to have fired his enthusiasm, and he continued to draw uncommissioned lithographs at erratic intervals throughout his career. His approach was always fresh and unpredictable; moreover he usually made no effort to publish them. These two factors mean that even now, after years of Manet scholarship, it is quite unclear when some of them were drawn. Manet also made numerous etchings, and it is remarkable how his treatment of the two media differed. By and large his etchings are reproductions of oils he had previously painted, whereas the lithographs are in the main independent compositions. This is curious when one considers how the *Société des Aquafortistes* laid such stress on originality in etching. One reasonable way to explain this is to follow Michel Melot in his introduction to the catalogue of the Manet exhibition at Ingelheim, and to point to Manet's strong respect for tradition. The intaglio processes of engraving and etching had since at least the seventeenth century been the standard reproductive techniques, and Manet found it hard – or did not wish – to break free of the weight of this tradition. By contrast, lithography, having only been invented in 1798, had no such tradition attached to it, and so Manet would have felt himself at liberty to handle it in any way he pleased. Another factor must have been the freedom of handling and texture which the lithographic crayon allows and which brings it nearer to the paint brush. This would have been far more

5. G. Hédiard: *Fantin-Latour*, Paris, 1906, pp. 15–16.
6. The episode has never been properly investigated. Manet's print is in this exhibition, no. 14. Legros' lithograph must be Poulet-Malassis 96 (cf. J. Bailly-Herzberg, *op. cit.*, vol. II, p. 135). Bracquemond's *Cavaliers* is Beraldi 750 (an impression is in this Department, 1927-3-12-291). Fantin-Latour's prints are Hédiard 1–4. We can find nothing about the print by Ribot.
7. A copy of this catalogue is in the Department library.

sympathetic to Manet than the single line which is all that can be produced with the etching needle.

Manet's lithographs may now seem among the greatest masterpieces of the print in the nineteenth century; but in his lifetime and for many years after they were virtually unknown to the general public because they were published in such haphazard fashion. As a result they had almost no influence and no effect on the history of lithography in France.

The beginnings of the historical revival may perhaps be traced back to 1873 when Fantin-Latour, who had abandoned lithography after 1862, took the medium up again. His prints are not very impressive and none is shown in this exhibition, but his example was significant in showing that there was a market for original lithographs. In particular he introduced a much more important artist, Odilon Redon, to lithography in 1879. Redon at this point was making numerous drawings in black charcoal and finding them very difficult to sell. The rich blacks transferred extremely well to the stone and the multiplication of images which lithography allowed brought his work to the attention of a small group of mainly Netherlandish collectors and patrons, who supported him through the rest of his career.

But for this reason it cannot be claimed that Redon popularized lithography. Because he sold either directly or through a few dealers to his collectors, he was hardly known to the general public. His example, however, may have had a wider significance. André Mellerio (Redon's cataloguer and perhaps a biased witness), writing in 1898, claimed of Redon that: '*la conception originale, la personnalité des procédés, la science et le soin d'exécution technique mantinrent la lithographie pendant une période presque mortelle de discrédit et de profonde indifférence.*'[8]

ANTONY GRIFFITHS

The 1890s

The last decade of the nineteenth century is a largely self-contained episode within the history of printmaking in France, anticipating many of the features which now characterize modern publishing and commercial selling practices in this field. '*La Rénovation actuelle de l'Estampe s'affirme chaque jour davantage*'; this profession of faith headed the programme printed in the first number of one of the specialized journals founded during the 1890s, *L'Estampe et l'Affiche*. The editor of the journal, André Mellerio, wrote the introductory article which traced the antecedents of the current enthusiasm for prints. He concluded by posing the social and artistic questions crucial to an understanding of the historical context of the revival: '*Quelles causes ont réveillé cette faveur pour l'estampe? Dans le public que s'est-il passé? Quelles*

8. *L'Estampe et l'Affiche*, 1, 1897, p. 5.

nécessités de la vie moderne, quels besoins nouveaux ont pu amener logiquement ce résultat?'[9]

In these years colour lithography was undoubtedly the most exciting and controversial form of graphic expression. Camille Pissarro's grumblings in 1896 about the lack of interest in engraving and the publishers' obsession with colour reveal the climate of taste: *'T'ai-je dit que la gravure en couleurs que me demande Vollard est une litho? J'aurais mieux aimé [la faire] en noir, mais il paraît que la couleur est à la mode.'*[10] Yet Pissarro had himself taken up lithography again in 1894 after a break of twenty years after accepting a publisher's commission (see 60). The increasing preponderance of lithographs over prints executed in other media can be traced in the two *Albums des Peintres-Graveurs* published by Vollard. His first album in 1896 had contained thirteen lithographs out of a total of twenty-two prints. The 1897 album contained thirty-two prints of which thirty were lithographs and of these all but six were coloured. The apogee of this burst of chromatic activity came during the last three years of the decade when a reviewer observed of the exhibition of the Société des Peintres-Lithographes: *'Partout la couleur chante, souvent même avec excès.'*[11] *Le Figaro*, which in 1895 had devoted a special issue to the massive exhibition marking the centenary of lithography, sponsored a further exhibition in 1897 solely for *'l'estampe en couleurs'*.[12]

The technical developments facilitating the sophisticated print production of the 1890s had been introduced and refined earlier in the century. Engelmann had received a French patent for chromolithography in 1837, and by the middle of the century the process was well advanced both in France and England. The very technical virtuosity displayed in these prints however militated against their acceptance by a serious critical audience and the use of colour was damned for its association with facile, commercial reproduction as opposed to original composition. The chief propagandists for the colour print during the 1890s, André Mellerio and Roger Marx, conducted a vigorous campaign to reclaim the use of colour from this debased connection, and attempted to establish a clear distinction between chromolithography as a purely reproductive process, and original colour lithography as an expressive medium in its own right. The distinction was somewhat invidious; *'l'estampe originale'* and *'le vulgaire chromo'* could not, in reality, be so easily divided, but the attitude was bred partly of the strictures levelled by protagonists of black and white lithography and partly of a snobbery encouraged by a new collectors' market. The debate about the artistic validity of colour sharply divided the artistic community. M. Henri Lefort, the president of the print section of the annual Salon, and the Société des Artistes Lithographes Français, justified the refusal to admit any colour print for exhibition on the

9. *L'Estampe et l'Affiche*, 1, 1897, pp. 3–6.
10. *Camille Pissarro, lettres à son fils Lucien*, ed. J. Rewald, Paris, 1950, p. 412.
11. *L'Estampe et l'Affiche*, 1, 1897, p. 90.
12. Op. cit., 1, 1897, p. 93.

grounds that: '*par ses principes essentiels, ses origines et ses traditions, l'art de la gravure est, sans contredit, l'art du Noir et Blanc.*'[13] But the Société des Peintres-Lithographes welcomed colour into its rival exhibition at the Champ-de-Mars.[14] By abandoning the despised nomenclature of '*chromolithographie*' in favour of '*lithographie en couleurs*', the apologists felt that a new art form had been invented: '*Mais l'heure paraît lointaine où le Polichinelle de Manet s'intitulait modestement chromolithographie!*'[15] Another reviewer commented à propos of Ernest Maindron's comprehensive study of the poster[16] that the second volume published in 1896 described its illustrations as '*lithographies en couleurs*' whereas the first volume of 1886 had naïvely referred to the reproductions of Cheret's posters as '*chromolithographies*': '*le mot chromolithographie n'a plus de valeur artistique et ne s'emploie plus.*'[17]

The career of the poster artist Jules Chéret was chosen by Henri Bouchot (who in 1899 was put in charge of the Cabinet des Estampes in the Bibliothèque Nationale in Paris) to exemplify the transition from chromolithography to the more elevated medium of colour lithography. Posters, and the work of this artist in particular, played a crucial role in stimulating a new interest in illustration, which encompassed song sheets, book jackets and theatre programmes, to which lithography easily lent itself. Ernest Maindron's book indicated that already in 1886 posters had begun to be collected and studied as serious works of art. The avidity with which posters were acquired during the 1890s prompted a flourishing illicit trade among the *afficheurs* and clandestine removals of the most prized examples. '*Les avant-lettres de ses [Chéret] jolies chromolithographies bariolées ont un débit colossal. Il n'est point rare de voir, à la nuit tombée, les amoureux pauvres et honteux arracher péniblement aux murs les épreuves collées dans la journée. Les plus heureux encadrent leurs 'états' et les suspendent dans leurs salons.*'[18] Demand was not directed solely at Chéret's productions; the connoisseurs lavished their praise equally upon artists like H. G. Ibels and Auguste Willette, whose work, like Chéret's, now appears vapid and dull by comparison with the dazzling talent of Toulouse-Lautrec. Roger Marx attributed the poster's popularity to the dissolution of the old hierarchies of artistic expression which enabled it to transcend the categories of taste dictated by social and economic circumstances: '*Comprise par tous les âges, aimée du peuple, l'affiche s'adresse à l'âme universelle . . . Son art n'a ni moins de signification, ni moins de prestige que l'art de la fresque.*'[19]

Mellerio expressed similar sentiments on the subject of *l'estampe originale* which he regarded as the quintessential form of contemporary artistic expression. Original lithography undoubtedly commanded a large audience through the medium of the contemporary press. Newspapers and journals often competed with each other for the rights

13. A. Mellerio: *La Lithographie Originale en Couleurs*, Paris, 1898, pp. 4–5. Together with Mellerio's articles in *L'Estampe et l'Affiche*, this book is crucial for an understanding of the period.
14. *L'Estampe et l'Affiche*, II, 1898, p. 114.
15. Op. cit., II, 1898, p. 117.
16. E. Maindron: *Les Affiches Illustrées*, Paris, 1886. Idem: *Les Affiches Illustrées 1886–95*, Paris, 1896.
17. *La Plume*, I, 1896, p. 44.
18. H. Bouchot: *La Lithographie*, Paris, 1895, p. 200.
19. *L'Estampe et l'Affiche*, I, 1897, p. 223.

to reproduce a leading artist's work, as happened in the case of Toulouse-Lautrec's poster of Jane Avril (see 91). But the journals most concerned with the commission and dissemination of original prints, for example *L'Estampe et l'Affiche* and *Les Maîtres de l'Affiche*, were designed to appeal to a highly select audience. Despite the claims made for the democratic nature of the medium, the most significant developments of the 1890s were determined by the market among specialist collectors who demanded limited editions and rare states, the accoutrements of the philatelic aspect of prints. Thus contemporary advertisements for prints make sharp distinctions in price between posters before and after letters, and lay great emphasis on the guarantee '*Pierres effacées*'.

The erratic practices of experimental printmakers like Manet, and of the older generation of Impressionists, were not commercially viable, and entrepreneurs intervened to establish publishing on an organized basis. The most important of the publishers of limited edition portfolios in the 1890s were André Marty and Ambrose Vollard. Marty was the pioneer, and his series, *L'Estampe Originale*, appeared in nine quarterly instalments between 1893–5, containing altogether ninety-five prints.[20] It achieved considerable success; it was published in an edition of 100 at a subscription price of 150 francs per annum (forty prints), and by 1898 was long sold out and was selling for 600 francs. Vollard's two albums did not sell so well. This must have been largely a matter of price: the first album of 1896 containing twenty-two prints sold for 150 francs, the second of 1897 with thirty-two prints was priced at 400 francs. As a result Vollard never published a third album he was planning; however, since he was making a fortune from his primary activity dealing in modern paintings he could well stand the loss. He was not discouraged from publishing sets of lithographs by Bonnard, Vuillard, Denis, Roussel and Redon in 1899. Indeed he seems to have treated all these activities, and the books which he published after 1900 as a hobby and a distraction from his main business.[21] These portfolios inspired numerous minor imitations of much lower quality such as *L'Estampe Moderne* and *L'Estampe Nouvelle*. The vogue also extended to literary journals. *La Revue Blanche*, edited by the Natanson brothers, included as a frontispiece to each number an original lithograph. These prints, originally published in unlimited editions, were then reprinted as a limited edition in an *Album de la Revue Blanche* (see 158).

Marty's and Vollard's portfolios included work by older artists like Fantin-Latour and Pissarro and foreigners like Rops, Munch, Shannon and Whistler. They were however dominated by the new generation of Toulouse-Lautrec and the Nabis – that is the group of artists around Bonnard and Vuillard who named themselves after the Hebrew word for a prophet. Colour lithography briefly provided them with an ideal

20. D. M. Stein: *L'Estampe Originale, a catalogue raisonné*, New York, 1970.
21. A. Vollard: *Recollections of a Picture Dealer*, London, 1936, pp. 247ff.

medium of self-expression; it was these artists who were patronized by the new journals as Pissarro wryly remarked: '*La boîte de la Revue Blanche me semble hostile, c'est la jeune école qui s'y trouve.*'[22] They drew much of their inspiration from Japanese prints, to which the public was increasingly exposed during the decade. The oriental influence was largely responsible for the Nabis' avoiding '*les mélanges excessifs aboutissant aux fadeurs prétentieuses du chromo*' in favour of broad, flat areas of unmodulated colour: '*un jeu large de colorations sincères ou l'oeil puisse s'étaler nettement*'.[23] This discovery was crucial to their success and was responsible for the new note which they managed to introduce into lithography.

The year 1899 was marked by the publication of five new portfolios by Vollard and the future prospects of the market must have appeared healthy. Yet after the next year everything had decisively changed. Vollard published no more colour lithographs and turned his attention to book illustration. Bonnard and Vuillard abandoned the medium, while Toulouse-Lautrec was a dying man. Even Chéret seems to have stopped making posters. Thus there is nothing in this exhibition after 1900. The transformation, even if overstressed here, is remarkable and makes the question of why the movement collapsed almost as puzzling as the question of why it suddenly arose in the early 1890s.

FRANCES CAREY

Lithography

Lithography is based on the chemical fact that grease and water repel each other. If marks are drawn on a suitable printing surface in some greasy medium, the surface can be used to print from in the following way: the surface is first dampened with water, which only settles on the unmarked areas, being repelled by the greasy drawing medium. Secondly the surface is rolled over with greasy printing ink, which will only adhere to the drawn marks, the water repelling it from the rest of the surface. Finally the ink is transferred to a sheet of paper by running paper and the printing surface together through a scraper press.

Such in essence is the principle of lithography. The actual operations are of course much more complicated. The printing surfaces used in the nineteenth century were of two types. Firstly there was stone (whence the term 'lithography' or 'stone drawing'), and the most suitable type was found to be the limestone quarried in the Solenhofen region of Bavaria. Later zinc was used as a substitute; there is usually no way of telling from inspection of any individual lithograph whether stone or zinc has been used. (Nor can it be assumed that zinc was necessarily used for huge works such as the Toulouse-Lautrec posters; Stanley

22. *Camille Pissarro, lettres à son fils Lucien*, ed. J. Rewald. Paris, 1950, p. 405.
23. A. Mellerio: *La Lithographie Originale en Couleurs*, Paris, 1898, pp. 33–4.

Pen lithograph (detail of 59)

Chalk lithograph (detail of 16)

Brush lithograph over chalk (detail of 63)

Jones informs us that colossal slabs of limestone were available.) The stone (and all that follows also holds true for zinc) can be drawn on in any way as long as the drawing medium is greasy; this explains the initially bewildering variety of appearances that lithographs can present. If pen is used the surface has to be smooth, but if chalk (crayon) or wash is preferred the surface has to be given a grain by rubbing on an abrasive.

Once the drawing is prepared the artist's task is finished; the remaining operations are the province of the printer. And these are complicated enough to make it most unusual for an artist to do his own printing; he might well supervise but he needs the expert's aid. (This distinguishes lithography sharply from etching, and fundamentally affects the whole history of the medium.) The difficulty is that the stone has to be prepared before printing, and the exact process of preparation varies according to the technique of the drawing. Briefly the stone must be processed chemically with gum arabic solution and dilute nitric acid in order to fix the image on the stone and to ensure that the undrawn areas hold the water. Only then can the surface be washed and inked for printing as described in the first paragraph. The flat-bed scraper presses continued in use throughout the century for small-scale work, but posters had to be printed on the large rotary presses, which were only perfected in the 1860s.

There is much evidence for the crucial importance of the expert lithographic printer. Thus Redon in *A Soi-Même*, p. 123: '*Rien de bon, rien de complet ne sera possible sans la collaboration attentive de cet acolyte, simple opérateur, dont la participation est précieuse quand elle est intuitive, néfaste et déplorable quand elle ne pressent ou ne devine rien.*'

Transfer Paper

Instead of drawing directly on the stone, the artist can use transfer paper. This is made by laying a soluble surface over a sheet of paper. The artist draws on this surface in the ordinary way, and the image is laid against a stone and transferred to it by means of moisture and pressure. Transfer paper has obvious advantages in ease of transport and in overcoming the difficulties of the reversal of the image in the printing operation; moreover the transferred image can easily be reworked on the stone. But the disadvantages are serious; the stone allows a much more full-blooded style of drawing than paper. A transfer lithograph can often (though by no means always) be distinguished from one directly drawn on the stone by the loss of definition and the tell-tale transfer of the grain of the paper.

Colour Lithography

One stone can only be inked in one colour. Thus in colour lithography there must be as many stones as there are colours (except in so far as

new colours are created by overprinting others), and each stone has to be separately drawn. The artist usually first makes a preliminary sketch of his composition, and from this prepares a keystone on which the composition is drawn in outline. Impressions pulled from this stone serve to transfer the image to the colour stones, on which the areas of each colour are drawn in. Finally the stones are inked with the desired colours, and are successively printed onto the one sheet of paper. Great care is needed both in the order of printing the colours and in the exact registration of the stones.

Paper

Various papers were used for printing in this period. Most of the lithographs were printed on ordinary wove or laid paper, and in the catalogue entries it may be assumed that where no attention is drawn to the paper one of these types was used. Nineteenth-century paper was however notoriously badly manufactured, and many artists preferred to use more expensive alternatives. Henri Bouchot (*La Lithographie*, Paris, 1895, p. 294) remarks that the paper used has condemned most French lithographs to speedy destruction, and praises the artists of *L'Estampe Originale* for their efforts to find better papers. Nomenclature of paper is not very exact; we have tried to follow the definitions of E. J. Labarre: *A Dictionary of Paper and Paper-Making Terms*, Amsterdam, 1937. *Chine appliqué* refers to the very thin sheet of China (also called India) paper used mounted onto a backing sheet of ordinary paper. Two Chines of different colours were occasionally employed (especially by Bresdin). A wide variety of other papers was also used appliqué, especially by Pissarro. One class of these, a rough textured laid paper with fibres of different colours, is called *Ingres*, (cf. cat. 70). *Japan paper* is a very thin imported paper of silky texture made from mulberry fibres; it was used in the 1890s as a luxury paper. (Stanley Jones says that there are no advantages whatsoever in using it.) A different sort of Japan paper which is very thick, tough, and cream in colour, can be distinguished as *Japanese vellum*. Both types of Japan paper were often imitated by Western manufacturers; such imitations are generally known as *simili-Japan*.

Bibliography: Stanley Jones, *Lithography for Artists*, London 1967

Catalogue

In the catalogue entries the *References* refer to the standard catalogues of each artist's work; these are fully described in the *Bibliography* given after the biographical note on each individual artist. Numbers in brackets prefixed by the letter L refer to F. Lugt: *Les Marques de Collections*, Amsterdam, 1921, and its *Supplément*, The Hague, 1956.

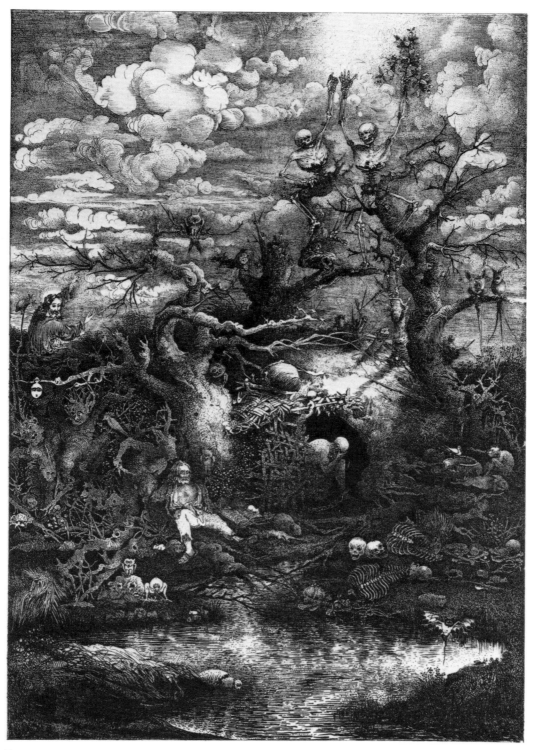

I

Rodolphe Bresdin

1822–85

Born at Le Fresne on the Loire; his father was a tanner. In the early 1830s the family moved to Paris. In 1838 he began to study art and frequent Bohemian society. 1845 saw publication of Champfleury's *Chien-Caillou* based on Bresdin's life; the nickname is a corruption of 'Chingachgook', the hero of Fenimore Cooper's *The Last of the Mohicans*. In 1848, after the Revolution, he moved to the south of France, and henceforth his life remained disturbed and impoverished: 1861 in Paris, 1862 to the south again, 1869 in Paris, from 1873 to 1877 a disastrous attempt to emigrate to Canada, 1877 to Paris, and finally in 1881 to Sèvres where, estranged from his family and with failing eyesight, he died in extreme poverty four years later.

Bresdin's bizarre way of life and Champfleury's book made him something of a legend even in his own lifetime. He tried to live from his drawings, etchings and lithographs (only one watercolour and no oil paintings are known), but the extreme rarity of most of his prints proves his lack of success; only two may be said to be common. His imagery is largely drawn from seventeenth-century Dutch art and nineteenth-century topographical prints, but is always given a uniquely personal elaboration which sets him apart from all his contemporaries. Although he began etching in 1839, he only took up lithography in 1854; from then to the end of his life he produced twenty, not counting the nine lithographic transfers of etchings (see 4 below). Although Bresdin regarded himself as an etcher rather than a lithographer, his lithographs are quite as important as the etchings. His lithographs were all carefully drawn in pen on a smooth stone, and this sets him apart from the main tradition of chalk lithography. Indeed Bresdin himself always referred to them as '*dessins sur pierre*', which suggests that he saw lithography as a means of reproducing his drawings. His influence was negligible, with the exception of that on Redon (qv), who left some interesting reminiscences of him. Bresdin also deserves to be remembered as a remarkable letter-writer.

Bibliography G = Dirk van Gelder, *Rodolphe Bresdin*, 2 vols, The Hague, 1976.

1 La Comédie de la Mort

1854
Two chines appliqués. 220 × 152 mm
Provenance Purchased from J. L. Rayner, Esq.
1920-5-12-43
Reference G84, from the fifth printing made in 1861.

This was Bresdin's first important lithograph, and, commercially, together with *The Good Samaritan*, the most successful of his career; van Gelder lists nine different printings of the stone. The first, rare printings were made in Toulouse in 1854 by the firm of Bertrand and Barthère; in 1861 Bresdin took the stone with him to Paris, and the reprintings were continued by Lemercier.

The Comedy of Death is not a traditional subject in western art, and Bresdin must have borrowed the title, and probably some of the imagery, from Théophile Gautier's cycle of poems published in 1838. The meaning of the print, although never yet seriously investigated, can be deduced from a letter Bresdin wrote in September 1854 to his friend Capin (reprinted by van Gelder, I, p. 195). He explained that his attempt to emigrate to America had been temporarily adjourned due to lack of money, and that he was trying to earn some by making lithographs (presumably this print). He continued:

En attendant, l'image de ce pays neuf, où la liberté et l'indépendance peuvent se conquérir par le travail, m'a déjà retrempé quelque peu . . . là où la nature dans sa sauvage splendeur vous offre, par son immensité luxuriante et créatrice, l'image de cette régénération future dont la religion nous prêche tant la croyance, la foi. Ah mon cher Capin, pouvoir, par un travail naturel à la face de Dieu et de la nature, cultiver son corps et son âme, développer les dons précieux que Dieu mit en vous, sans abrutir son corps dans un travail abrutissant, abject, souvent vil et infame, vendant son corps et son âme, asservissant son intelligence à l'oppression, à la ruse, la duplicité et la force, comme l'on voit tant de créatures déchues le faire pour gagner leur existence.

The image thus has a primary meaning as Christ offering a regeneration from worldly oppression, while the secondary, personal significance for Bresdin lay in his forthcoming escape from slavery in Europe to freedom in America.

2 Le Bon Samaritain

1861

Two chines appliqués. 564 × 444 mm. The pencilled name of the artist is not a signature.
Provenance Purchased through the artist Emil Orlik from the artist's daughter, Mlle Rodolphine Bresdin, together with seventeen other prints by her father, for £12.
1903-11-18-22
Reference G 100, from the third or later printing.

Bresdin's masterpiece, and by far his largest print, *The Good Samaritan* was begun in Toulouse early in 1861 and finished in Paris by the end of March. It was shown in the Salon that year together with five other works under the title of *Abd-el-Kader secourant un chrétien*; Thoré, the famous critic who rediscovered Vermeer, singled the group out as '*les dessins les plus singuliers de l'Exposition*'. Its success earned him the commission to do ten etchings for *La Revue Fantaisiste*, a periodical founded by Théophile Gautier to whom Bresdin had been recommended by Baudelaire. In November however he returned to the south shortly before the *Revue* collapsed; never again was it likely that he might make a living as an artist.

Bresdin's treatment of the scene from the Biblical parable (Luke x 30) is highly original; the two figures are almost lost in the wealth of exotic detail. The title used in the 1861 Salon is unexplained; Bresdin himself seems invariably to refer to this print as *Le Bon Samaritain*. The sale of this print was Bresdin's major source of income for years; in a letter of 1883 he refers to '*ce bon Samaritain si bien nommé et qui m'a sauvé tant de fois*'.

3 Frontispiece for the *Fables et Contes* of Thierry de Faletans

1868

245 × 199 mm. The impression is very severely trimmed and stuck down on to another sheet of paper. This is characteristic of the work of Mlle Bresdin (cf. van Gelder, I, p. 11).
Provenance Purchased from Mlle Bresdin. 1903-11-18-18
Reference G 122, first state.

After 1861 Bresdin abandoned lithography for several years. He was persuaded to take it up again in 1868 by a commission from the eccentric Comte de Faletans to illustrate a book of fables that he had written. The history of this commission is comic; Bresdin and Faletans never met, and correspondence had to travel from Paris to Bordeaux. Faletans issued absurd instructions about what was to be drawn, and continually refused Bresdin's proofs. This frontispiece was turned down in a (lost) earlier state. Bresdin then vented his fury on the image, writing on the stone where the title was to be: '*Calvaire du vieux Caillou*' and '*Ha qui me delivrera des pigouffes*'. Later, in 1878, he substituted an even more bitter inscription on the rock: '*Je porte cette pierre depuis 50 ans*'. He did however make a new title-page and six other prints which were accepted. The book, when finally published in 1871, was hardly a success; only one copy is now known.

The style of the frontispiece – a window framed by foliage – was not uncommon in nineteenth-century book illustration. A close parallel is provided by the frontispiece to the 1838 edition of Saint-Pierre's *Paul et Virginie*, (illustrated in A. Nesbitt: *200 Decorative Title-Pages*, New York, 1964, plate 140). This was perhaps the most famous French illustrated book of its period. It was obviously well known to Bresdin, for it is one of the most important, although neglected, sources of his style.

4 Le Repos en Egypte, à l'âne bâté

1871

Chine appliqué. 229 × 197 mm. With the artist's stamp in red (L 295b).
Provenance Presented by J. L. Rayner, Esq. 1921-6-22-1
Reference G 138, transfer of the first state of the etching.

No impression of the etching, in its first state of 1871, survives. In 1873 Bresdin was about to emigrate to Canada, and, in order to get more material to sell there, he instructed Lemercier to transfer seven etchings to lithographic stones and print 110 impressions of each. The process is very simple, and is fully described by A. Lemercier: *La Lithographie Française*, Paris, 1896, pp. 139–144. An impression from the copper plate is printed on to a sheet of paper in a special transfer ink; the paper is then laid flat against a lithographic stone. The design, thus transferred, will print in the same direction as the original etching. Although rarely found in fine prints, this process was very widely used in the nineteenth century for commercial printing; nearly 100,000 impressions of a transfer of the engraving of Wilkie's *Rent Day* were sold in England by mail-order firms, (cf. A. W. Tuer: *Bartolozzi and his Works*, London, 1885, chapter 36). Bresdin is also

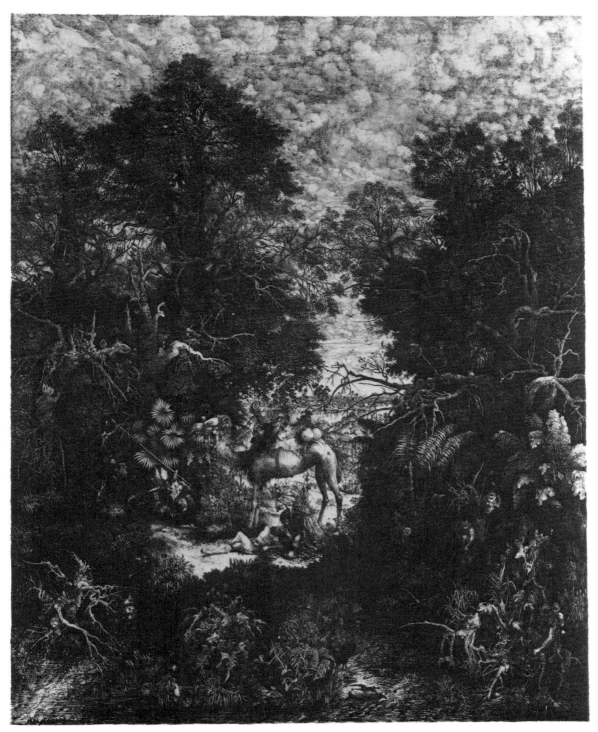

2

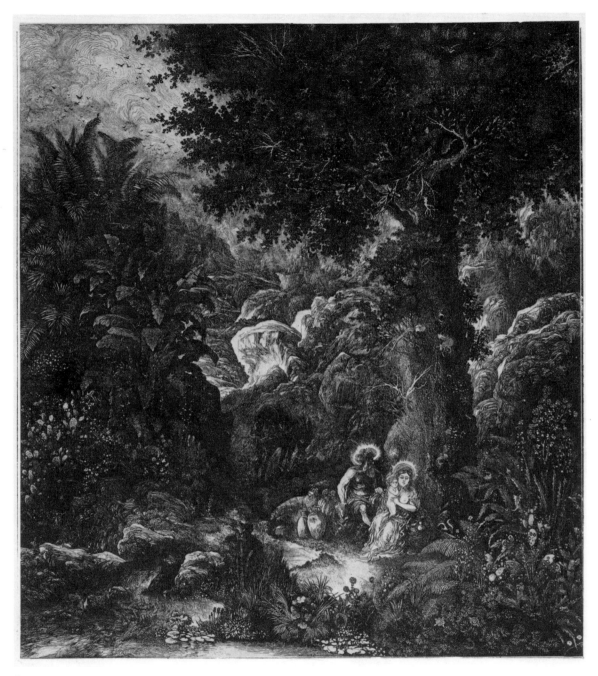

4

7

known to have transferred impressions of his lithographs to a second stone.

The red stamp was used by Bresdin after 1865 on particularly fine impressions of his prints. According to van Gelder it is only found rarely.

5 Le Repos en Egypte, à l'âne bâté

Etching. 229 × 197 mm
Provenance Purchased from J. L. Rayner, Esq.
1920-5-12-42
Reference G 128, second state.

Since no impression of the first state of the etching is known, we show an impression of the second state which was drastically reworked in about 1880. But the underlying design of the first state which had been transferred in 1873 can be made out.

6 La Pêche Miraculeuse

1883
482 × 310 mm. Numbered in pencil on the verso *no. 2*, with a second faint impression of the image.
Provenance Purchased from Mlle Bresdin. 1903-11-18-21
Reference G 151, one of four known impressions.

This is one of Bresdin's most attractive prints. The title was given by the artist. It carries connotations of the miraculous draught of the Bible (Luke v, 1–11), although these references would not be suspected from the image itself.

Visually these late prints differ markedly from the earlier ones. Stanley Jones however is certain that the technique is still pen drawing on stone; the peculiar appearance is entirely due to bad printing. Confirmation of this is found in a letter of 1883 in which he sends what must be an impression of this print to his friend Dusolier:

Après des accidents inénarrables dûs à la mauvaise étoile qui me poursuit, et par l'ineptie des ouvriers qui préparent les pierres chez Lemercier, voilà deux superbes dessins qui m'ont coûté quatre mois de travail et des privations inouies.
(Reprinted by van Gelder, I, p. 205.)

7 Le Gave

1884
Grey chine appliqué. 369 × 313 mm. Numbered in pencil on verso *no. 3*.
Provenance Purchased from Mlle Bresdin. 1903-11-18-20
Reference G 153, probably from the posthumous reprinting of *c*. 1899.

This is Bresdin's last print, done in the year before his death, when he was living in complete indigence at Sèvres, near Paris. As with the previous lithograph, this stone was mangled in the printing. Bresdin was obviously most dissatisfied, and on one impression effected an astonishing transformation with grey and white gouache, (in the Louvre, illustrated by van Gelder, I, p. 142). Instead of a stream falling through a gentle valley, we see a high waterfall set among snow-capped mountain peaks. The unforced fantasy makes this drawing his finest achievement; had he survived longer, one thinks, he might have broken out of the rather limited vein which his earlier work had exploited.

Gustave Courbet

1819–77

Born at Ornans, south-east of Besançon; in 1840 settled in Paris. From 1849 he was recognized as the leader of the realist movement in painting. After the Commune of 1870 he was held responsible for the destruction of the Vendôme Column, and in 1873 was forced into exile where he died.

Courbet, although a central figure in French painting, plays only a marginal role in the history of lithography. But his one significant lithograph is so singular that it merits inclusion in this exhibition.

8 L'Apôtre Jean Journet

1850
244 × 171 mm (image only); 390 × 300 mm (with lithographed text)
Provenance Purchased from Messrs Ernest Brown and Phillips. 1920-5-12-41
Reference T. Duret in *Gazette des Beaux-Arts*, XXXIX, 1908, p.424.

The lithograph shows *L'apôtre Jean Journet, partant pour la conquête de l'harmonie universelle*. The twenty-two verses of complaint, of unknown authorship, are put into the mouth of Journet, and are to be sung to the tune of *Joseph*. Jean Journet was a disciple of Fourier, the pioneer French socialist, and was a well-known eccentric; like Bresdin, he provided the subject for an essay by Champfleury, published in 1847. Courbet was himself a Fourierist in the 1840s, and the lithograph

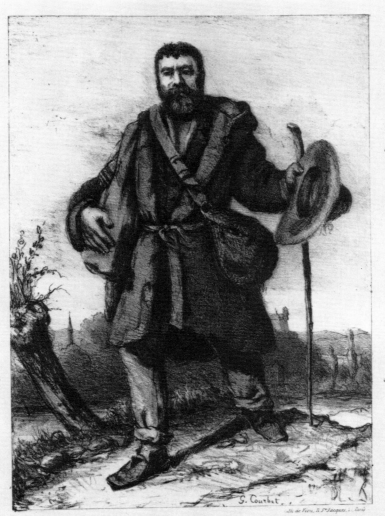

9

reproduces a portrait in oils which Courbet had painted earlier in 1850; this was exhibited in the Salon of 1850–1, but is now lost.

The print belongs in respect both to its form and to its publisher to the class of popular rather than fine art prints. In this it stands far apart from the other lithographs in this exhibition. Courbet's commitment to realism also led him to adopt popular imagery in his works; the same woodcut of *The Wandering Jew* served for this portrait and for the famous *Meeting* of 1854 in the Museum at Montpellier. (cf. M. Schapiro: *Journal of the Warburg and Courtauld Institutes*, IV, 1940/1, pp. 164 ff; L. Nochlin: *Art Bulletin*, XLIX, 1967, pp. 209 ff.)

Jean François Millet

1814–75

Born at Gruchy, near Cherbourg; his parents were peasants. 1837 student in Paris; in 1847 first attracted attention at the Salon. From 1849 to the end of his life lived in the village of Barbizon, painting landscapes and highly charged scenes from peasant life.

Like Courbet, Millet is only a minor figure in French lithography. Delteil catalogues six, of which only three are unquestionable; a fourth was first printed in 1920. His etchings are much more significant.

Bibliography D = L. Delteil: *Le Peintre-Graveur illustré*, I, Paris, 1906.

9 Le Semeur

1851
The original stone, cancelled. 276 × 218 mm
Provenance Presented by Mrs David Keppel. 1957-6-20-2

10

Lithograph from the above stone. 191 × 156 mm
Provenance Presented by Mr F. Keppel. 1901-10-15-44
Reference D 22, second state.

Millet produced many versions of this composition; the earliest (now in Cardiff) is of 1846–7. The most famous version was shown at the Salon of 1850–1. It was generally praised by the critics, and Millet was commissioned by *L'Artiste*, the leading French artistic magazine of the period, to make a lithographed reproduction. It has recently been established that Millet and his adviser Sensier suppressed the publication, being dissatisfied with the quality. (See the Exhibition Catalogue, *Millet*, Arts Council, 1976, nos. 36–7.) The stone survived and was reprinted steadily from 1879, first by Mme Millet and then (almost certainly) by Keppel, the American dealer. It is unclear at what stage the stone was cancelled; the fact that it was inscribed *CANCELLED* shows that this was not done in France, but the initials *CF* (or *FC*) are not yet explained.

Camille Corot

1796–1875

Began practising as an artist in 1822 with an allowance from his father. In Italy 1825–8, and again in 1834 and 1843. From the 1840s extremely successful. A very simple and very kind man, he had considerable influence on the generation of the Impressionists.

Apart from three unimportant pieces, all Corot's sixteen known lithographs were made late in his life. He seems to have had no interest in lithography as

such. All were drawn on transfer paper, and the rest left to the printer. So inexpert was he, that in one case (D29) he actually drew on the wrong side of the transfer paper; the design was only saved by virtuoso feats at Lemercier's.

Bibliography D = L. Delteil: *Le Peintre-Graveur illustré*, v, Paris, 1910.

11 Saules et peupliers blancs

1871
Chine appliqué. 393 × 258 mm. There is a hole torn in the centre.
Provenance Purchased from R. Gutekunst, Esq.
1914-10-12-141
Reference D 30, second state with Lemercier's address (extremely faint) and with a blindstamp *Dessins Originaux édités Rue Lafayette 113 Paris.*

This is the ninth of a set of twelve lithographs published in an edition of fifty by Lemercier in 1872. According to the notice on the cover of the folder, Corot had made the drawings on transfer paper during the course of his stay at Arras and Douai in 1871 with his friend and biographer Alfred Robaut. It is said to have been Robaut's suggestion that Corot make the set, and he saw to its publication.

12 Le Fort détaché

1874
Bulle volant. 265 × 182 mm
Provenance Dodgson bequest. 1949-4-11-3191
Reference D 32

This and the next lithograph were published in editions of 100. Both were drawn on transfer paper at Arras in July 1874, again presumably at Robaut's suggestion.

13 La Lecture sous les arbres

1874
Bulle volant. 260 × 184 mm
Provenance Purchased from Messrs Colnaghi. 1915-4-8-33
Reference D 33

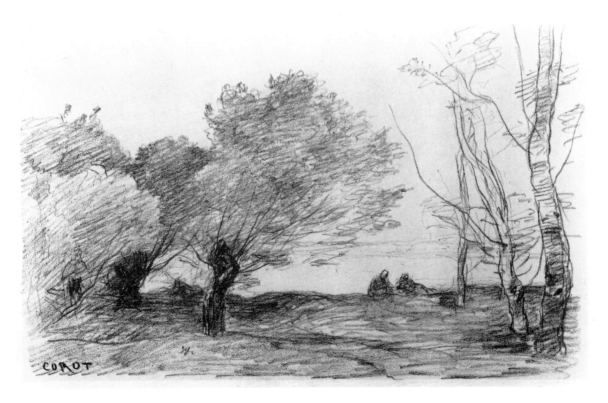

11

Edouard Manet

1832–83

Born in Paris, the son of a government official. In 1850 joined the studio of Couture. 1861 first paintings exhibited at the Salon; the exhibition of *Olympia* in 1865 caused a scandal, and to the end of his life Manet remained both famous and highly controversial.

Manet's first prints were made in 1860. His complete oeuvre consists of seventy-five etchings and twenty-five lithographs. Of the latter barely half was published in Manet's lifetime.

Bibliography
G = M. Guérin: *L'Oeuvre Gravé de Manet*, Paris, 1944.
W = J. Wilson: Catalogue of the exhibition, *Edouard Manet, Das graphische Werk*, Ingelheim am Rhein, 1977.
RW = D. Rouart and D. Wildenstein: *Ed. Manet, Catalogue Raisonné* (of paintings and drawings), 2 vols, Lausanne, 1975.

14 Le Ballon

1862
On a coarse-fibred paper. 403 × 515 mm
Provenance Dodgson bequest. 1949-4-11-3334
Reference G 68; W 28

This is one of only five known impressions of this print; the other four are in the collections of the Bibliothèque Nationale, New York Public Library, Fogg Art Museum and (formerly) M David-Weill. The circumstances of the commission are discussed in the introduction (p. 12). The print is signed on the stone in the bottom right corner; the date is always read as 1862, but the last figure is illegible.

In many ways this print stands alone in Manet's work. Not only is it unrelated to any surviving drawing or painting, but the style of drawing is very different from that used in the other major lithographs. In 1862 Spanish influence on Manet was at its strongest; in his etchings he modelled his manner on Goya, and in this print the style is taken directly from Goya's set of four lithographs known as *The Bulls of Bordeaux* of 1825. Particular 'Spanish' figures can be made out: the cripple in the foreground, the water-carrier, the soldier with the broad sash round his waist. The manner of handling the lithographic crayon has nothing in common with contemporary French practice, and indeed goes far beyond Goya's in its vigour. The lack of preparatory drawings tends to confirm the immediate impression that Manet composed directly on the stone.

The subject has not, as yet, been related to any particular balloon ascent. But it is unlikely that this was so; ballooning was very common and popular at this period, and spawned a large production of ballooning prints. It was probably the existence of this specialised genre that led Manet to choose this subject when asked by Cadart to do a lithograph.

15 L'Exécution de Maximilien

1868
Chine appliqué. 336 × 433 mm
Provenance Dodgson bequest. 1949-4-11-3346
Reference G 73; W 54, first state before lettering; the chine has wrinkled in the press.

Maximilian, Archduke of Austria, was made Emperor of Mexico in 1863 largely through Napoleon III's machinations; left defenceless by the withdrawal of French troops, he was shot by the Liberal army on 19 June 1867. The news caused a sensation in Europe, and Manet made five versions of the subject, four oils plus this lithograph, which does not correspond exactly with any of the paintings. The behaviour of Napoleon III throughout the Mexican episode was quite disgraceful; thus the very choice of this subject could not be other than an attack on his régime. Manet drove the point home by his dispassionate treatment of the subject, and by clothing the execution squad in uniforms very similar to those worn by the French army.

Not surprisingly Manet was informed that if he insisted on presenting the picture for the Salon of 1869, it had 'toutes les chances pour ne point être admis'. To counter this he seems to have made the lithograph for wide public circulation. But when the printer Lemercier registered the print at the Dépôt Légal, 'ordre fut immédiatement donné de ne point laisser mettre en vente cette composition, quoiqu'elle ne porte point de titre'. Manet then had a quarrel with the printer Lemercier who preferred to destroy the stone rather than return it to Manet. The lithograph itself was first published posthumously in 1884. (These previously unnoticed documents are published in full in the *Burlington Magazine*, November 1977, p. 777.)

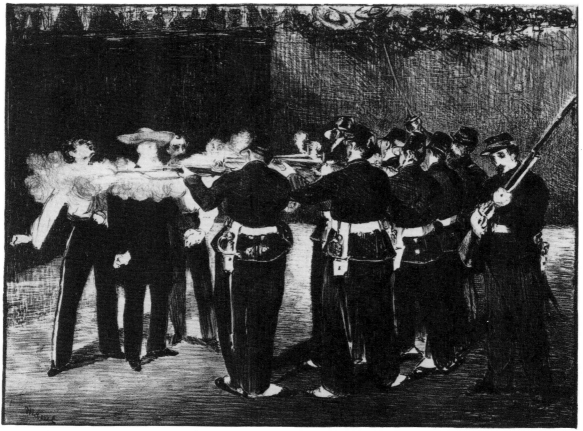

15

16 Les Courses

late 1860s
Chine appliqué. 365 × 514 mm
Provenance Dodgson bequest. 1949-4-11-3340
Reference G 72; W 66, second state, before lettering.

Our impression belongs to the second state. There is a hitherto undescribed first state of which an impression was exhibited at Ingelheim in 1977; in this the drawn area extends a further five millimetres on the right hand side.

The dating of this print is vexed. It is closely related in reverse to a gouache dated 1864 in the Fogg Art Museum, and to an oil at Chicago. Jean Harris, in an article devoted to this subject in the *Art Bulletin* of 1966, has argued that Manet painted a large race-track scene (now lost) in 1864, of which the composition is preserved in the Fogg gouache. She dates the Chicago oil later (*c.* 1865–9); then, since the lithograph is closer in composition to the gouache than to the oil, she dates it to 1865. The handling is however so different from that of *Le Ballon* of 1862 that the lithograph must be placed much later. It was only published in 1884.

This is one of Manet's most exciting prints. The furious scribblings of the crayon produce a wonderfully rich texture of blacks and greys. The composition is also startling with the low viewpoint and the impossibly curving right barrier.

17 La Barricade

1871
Chine appliqué. 464 × 330 mm
Provenance Dodgson bequest. 1949-4-11-3337
Reference G 76; W 72, second state, with lettering.

Both this print and *Guerre Civile* were inspired by

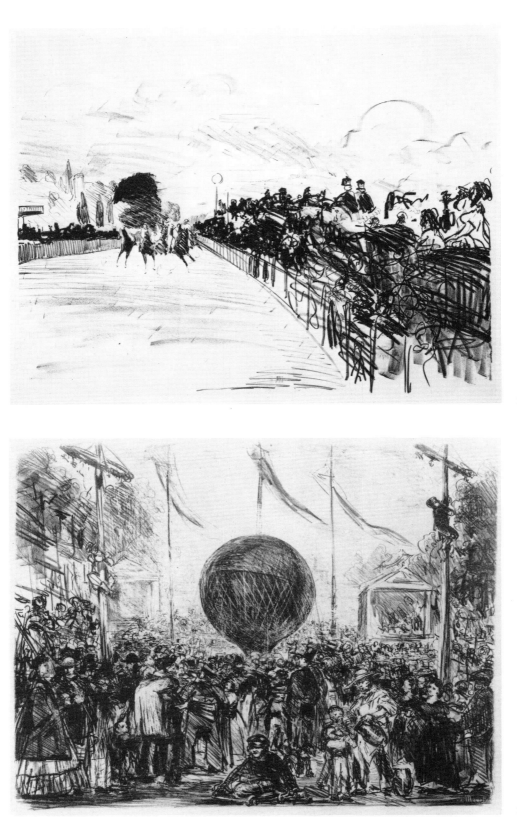

16

14

34

Imp. Lemercier & Cie Paris

17

scenes from the Commune – the civil war between Paris and the rest of France which followed the French defeat in the Franco–Prussian war. The battle was fought with appalling savagery for a week in May 1871 and left 20,000 Communards dead. Here a Communard is being summarily executed by the National Guard in front of a makeshift barricade.

The lithograph provides an interesting example of Manet's creative process. It will be noticed that the six members of the firing squad in this print are an almost exact replica in reverse of the first six soldiers in *L'Exécution de Maximilien*. A drawing in Budapest (RW 319) has on the one side a tracing which reproduces in reverse the soldiers from *L'Exécution*. On the other side is Manet's first idea for this composition, and it appears that the firing squad has simply been traced through from the other side. One consequence of the reversal is that all the soldiers in the lithograph are left-handed.

18 Guerre Civile

1871
Chine appliqué. 397 × 508 mm. Signed and dated on the stone.
Provenance Dodgson bequest. 1949-4-11-3336
Reference G 75; W 73, second state, with lettering.

Manet returned to Paris for the last days of the Commune. Duret, his friend and biographer, wrote of this print: '*La scène n'a point été composé. Manet l'avait réellement vue, à l'angle de la rue de l'Arcade et du boulevard Malesherbes; il en avait pris un croquis sur place.*' Although the drawing does not survive, evidence to support Duret's assertion can be found in the colonnade of La Madeleine which can be seen in the background of the print. This makes it all the more remarkable that the pose of the dead National Guardsman is the same, in reverse, as the dead Toreador of Manet's painting of 1864 now in Washington. This in turn is derived from a seventeenth-century painting now in the National Gallery in London (no. 741). The companion print is also based on an earlier work; thus what is apparently reportage can be shown to have its roots as much in art as in life.

As with *The Execution of Maximilian*, Manet could hardly have chosen a more sensitive subject. Although he probably intended the prints as a general condemnation, when it came to publishing them, *The*

Barricade was perhaps imagined to run the risk of being thought pro-Communard; thus only the more obviously neutral *Civil War* was published in 1874 in a small limited edition of 100, while *The Barricade* was only published posthumously in 1884.

In the lithograph Manet has used most successfully the side of the lithographic crayon to create broad slabs of grey. These are reinforced by numerous vertical scratchings out.

19 Le Gamin

early 1870s
Ingres paper appliqué. 289 × 228 mm
Provenance Dodgson bequest. 1949-4-11-3341
Reference G 71; W 45, second state, published in an edition of 100 in 1874.

The dating of this print has caused much controversy. It has often been dated to 1862 because an etching which Manet did of the identical subject and composition is securely dated to that year. On the other hand Léonce Rosenthal recognized that the print could not stylistically be dated to the same year as *Le Ballon* and preferred 1874. The only new evidence is Juliet Wilson's discovery (in the Dépôt Légal) that the edition of 100 was in 1874, which provides a *terminus ad quem*. The juxtaposition in this exhibition with the *Berthe Morisot* of 1872 should show that the two cannot be dated far apart. This is a very good example of Manet's economy as an artist, and the way in which he would take up the same theme again after a lapse of years.

The etching of 1862 reproduces in reverse a painting of the same period (in a private collection, RW 47); the motif of boy, basket and head of dog can be traced back to a painting by Murillo in the Hermitage (A. L. Mayer: *Murillo*, 1913, p. 207). Curiously, although the etching of 1862 is almost certainly later than the painting, the lithograph is much closer to the painting than to the etching.

20 Berthe Morisot (in silhouette)

1872
Chine appliqué. 218 × 164 mm
Provenance Dodgson bequest. 1949-4-11-3339
Reference G 78; W 74, second state, with lettering.

Manet was introduced to Berthe Morisot in 1868 by Fantin-Latour. In 1876 she married his younger

brother Eugène. In 1872 Manet made a portrait of her in oils (RW 179) and it is assumed that this outline lithograph, which corresponds very closely in design, was made shortly afterwards. Rouart-Wildenstein catalogue as a drawing (RW 389) what must be an impression of this lithograph; not only is the reproduction that they give of it indistinguishable from the print, but the measurements (175 × 140 mm) also tally almost precisely with the drawn area of the lithograph.

21 Berthe Morisot (in black)

1872
Chine appliqué. 204 × 143 mm
Provenance Dodgson bequest. 1949-4-11-3338
Reference G 77, W 75, second state, with lettering.

This is a free version of the same portrait as the preceding print. There seems to be no way of telling which of the two versions was made first. Neither was published until the edition of 1884 after Manet's death.

The format which is usually employed for cataloguing prints only recognizes differences of state as defined by alterations on the stone or plate. This however – as is obvious – will very rarely be adequate to capture the full complexity of the printing history of a stone. This lithograph provides a case in point. It has always been celebrated as the best example of Manet's technique of enlivening a rich black surface by scraping and gouging the stone. But the Cleveland Museum of Art possesses an impression of the first state (before letters) where there is very delicate modelling on the right side of the face. This has disappeared in the 1884 edition. Probably it went in the course of preparing the stone for that edition. If so there would exist examples of the first state but without the modelling (i.e. trial proofs of 1884). Finally the Victoria and Albert Museum possesses a 'first state' printed on simili-Japan; but the very poor quality of impression shows that it is later than the 1884 edition with the letters removed.

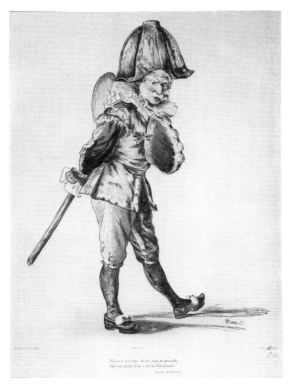

22

22–23 Polichinelle

1874
22

1. On Japan paper. 463 × 337 mm. Initialled by the artist and numbered 6.
Provenance Dodgson bequest. 1949-4-11-3342
Reference G 79; W 90, third state, from the first edition of twenty-five of 1874. Seven stones were employed.

23

2. On wove paper. 463 × 337 mm
Provenance Dodgson bequest. 1949-4-11-3343
Reference G 79, W 90, third state. From the second unlimited edition in 1874, printed from the same stones as the first edition.

Polichinelle (Punch) was a traditional figure in the Commedia dell'Arte, and the subject had been popularized in France in several works by Meissonier. A visitor to Manet's studio in December 1873 saw an oil of Polichinelle completed (presumably RW 213) and watched Manet doing a watercolour of another Polichinelle who was posing for him. It was

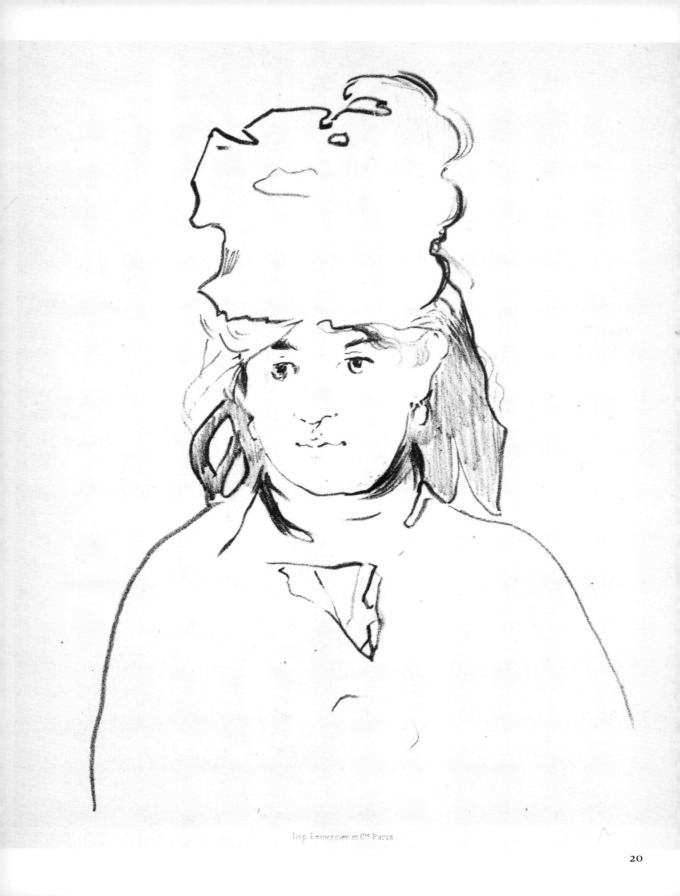

Imp. Lemercier et Cie Paris.

20

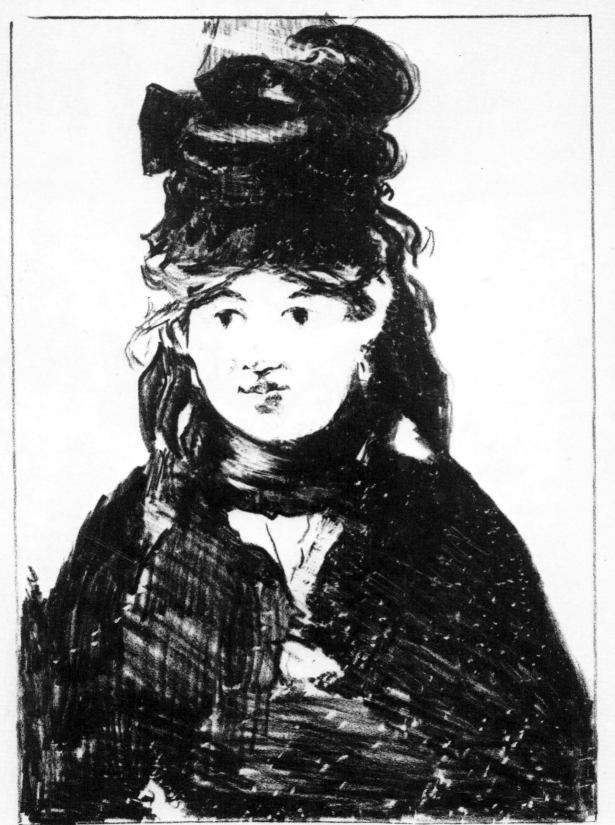

Imp. Lemercier & Cie, Paris

presumably this last watercolour which was exhibited in the Salon of 1874, no. 2357, (RW 563, now in a private collection). The lithograph here exhibited is a precise reproduction of the watercolour. We know from a letter of Manet to Prunaire (published by J. Adhémar: *Nouvelles de l'Estampe*, no. 7, 1965, pp. 232–3) that he had intended to exhibit the lithograph as well at the Salon; this did not in fact happen, but it has recently been discovered (by Wilson) that both the editions of the print were published in 1874. It had previously been thought that the first edition belonged to 1876, that the second edition was posthumous and that new colour stones had been made.

In an article published in 1923 the nephew of Lemercier's printer gave an account of the history of the print: he said that it was originally intended to be published in an edition of 8,000 to be distributed as a free gift to the subscribers to *Le Temps*; the police however thought that it was a caricature of Marshall Mac-Mahon, the French president, and banned the publication. The second part of this is dubious, but there is confirmatory evidence for the first part. Moreau-Nelaton published two letters of Manet (reprinted by Guérin, p. 19) which show that on 10 May (nine days after the opening of the Salon), Manet was offering the stones to the editor of the *Journal des Deux Mondes* for 2,000 francs. On 10 October he was still trying to find a buyer, and Lemercier, the printer, either had erased or was threatening to erase the stones. In 1876 Manet had still not paid Lemercier's bill. The fact that the print was to be a free handout with a magazine explains its exceptional nature in Manet's oeuvre. It puts it firmly in the context of nineteenth-century chromolithography, and shows that the usual position given to this print as the forerunner of the revival of artistic colour lithography is quite misleading. The limited edition would be an 'édition de tête', signed by the artist, on superior paper, while the unlimited edition used ordinary paper.

One further question which has never been seriously discussed is how far the print is indeed by Manet. The print is a very precise facsimile of the drawing, and this is quite foreign to Manet's usual way of working. Moreover a comparison between the second and the third states reveals numerous small adjustments to the black base stone, while major adjustments have been made to the colours; thus in the second state there is a beige ground tone over which white highlights have been printed from a second stone, whereas in the third state both ground tone and highlights are replaced by a newly drawn beige stone against white paper. This reveals unmistakably the expert hand of the professional chromolithographer. Evidence to support these suspicions can be found in Manet's letter to Prunaire of 1874 where he says: '*Je voudrais bien qu'on s'occupe de mes pierres Polichinelle . . . Un mot pour me dire un jour d'essai*'. This strongly suggests that the artisans were to hurry up and prepare the stones, and then Manet would come and correct the proofs – exactly as we find between the second and third states. Prunaire himself is only known to have been active as a reproductive wood-engraver; in this same year he did a wood-engraved reproduction of *Le Chemin de Fer* (Guérin 89), Manet's only other exhibit in the 1874 Salon, and of another drawing by Manet (Guérin 90), of which Guérin owned a proof corrected by Manet. Perhaps in this case Manet only did the black stone, while the colour stones were professionally prepared from the original watercolour, (cf. Cézanne, 84). Unquestionably it belongs to a time when Manet was trying to broadcast his art as widely as possible. 1874 was the year of the first Impressionist exhibition, when the Impressionists, in despair at their failure to get into the Salon, decided to try to establish themselves by holding a group exhibition; Manet, although equally unfortunate in the Salon, refused to participate, still wanting official respectability as an artist. Probably he intended these reproductions to serve the same purpose for himself as the exhibition served for the Impressionists.

The inscription was supplied by Théodore de Banville at Manet's request. Mallarmé and Cros, among others, also contributed verses which were not used.

24 Premier essai pour la tête du corbeau

1875
Transfer lithograph printed on chine appliqué.
250 × 320 mm. Inscribed in pencil: *Janv. 1875. 2 épr. sur chine.*
Provenance P. Burty (according to Guérin, who says that the pencil note is in Burty's hand); E. Degas (sale 6 November 1918, lot 286); M. Guérin (L 1872b), (sale 23 March 1926, lot 46); Dodgson bequest. 1949-4-11-3344
Reference G 84; W 93, one of three known complete impressions.

This very rare sheet is exceptional in Manet's oeuvre.

24

The date given by Burty of January 1875 is certainly correct since the raven's head is linked with the illustrations to Poe (see 25). The three studies of the head of a Pekinese closely follow three pencil drawings at Hamburg (RW 647 to 649); Manet also painted a portrait (RW 234) of the dog, Tama, which belonged to Théodore Duret and had been brought back from Japan by him in 1872 when he accompanied Cernuschi's expedition. The third part of the design (seen sideways) consists of facsimiles of eleven signatures of Japanese netsuke cutters, lettered from A to K. We have failed to identify Manet's source, but there is no reason to think that the writing was added by the printer to fill the gap, as was suggested by Moreau-Nelaton.

The fact that two elements of this design are securely Japanese makes it very likely that the head of the raven too was intended as an attempt at 'Japonisme', and there are very close parallels to the style of brush drawing in Japanese woodcuts. It follows from this that Manet thought of all the Poe illustrations as 'Japanese'

in style; the need to get brush effects would explain why he adopted the unusual technique of transfer lithography. Certainly Ernest Chesneau in an article on 'Le Japon à Paris' in 1878 claimed that Manet owed to Japan in these illustrations '*ses franchises de taches et l'esprit de la forme curieuse*'.

25–29 LE CORBEAU
1875

Manet's most important essay in book-illustration, *Le Corbeau* was published in 1875 by Richard Lesclide in Paris, in a limited edition of 240 copies, signed by the authors. It contained the English text of Edgar Allan Poe's poem 'The Raven', with a facing French translation by Stéphane Mallarmé. In the four openings so formed were inserted four full-page lithographs by Manet, who also provided a head of a raven to be printed on the front cover, and a loose print of a raven in flight to be used as an ex-libris. A poster announcing the publication informs us that the lithographs were printed on laid or China paper and that the book cost

25 francs; for an extra 10 francs one could acquire a second set of the illustrations.

Manet and Mallarmé first met in 1873, when Mallarmé was still an obscure poet, and became very close friends. When two paintings of Manet were rejected for the Salon of 1874 Mallarmé came to his defence in an article published in *La Renaissance artistique et littéraire*. The friendship resulted in Manet's illustrating both *Le Corbeau*, published in May 1875, and *L'Après-Midi d'un faune*, published in 1876; he also painted a portrait of Mallarmé (now in the Louvre) in 1876. No direct evidence seems to survive concerning the genesis of *Le Corbeau*. But we know that Mallarmé was continuously concerned to get artists to illustrate his works, (cf. L. J. Austin: Mallarmé and the Visual Arts, *French Nineteenth-Century Painting and Literature*, ed. U. Finke, Manchester, 1972, pp. 239–41), and in 1881 Mallarmé wrote to solicit Manet for further illustrations for his translations of Poe. But how closely Mallarmé influenced Manet's choice of subject or method of illustration cannot be discovered.

In the context of nineteenth-century book illustration Manet's designs are revolutionary; their size is exceptional and this seems to be the first use of brush lithography. They did not have much influence but enjoyed a considerable success. It even reached England. Rossetti wrote to Jane Morris in 1881:

Bye the bye, my own memento of O'S [O' Shaughnessy] is a huge folio of lithographed sketches from the Raven, by a French idiot named Manet, who certainly must be the greatest and most conceited ass who ever lived. A copy should be bought for every hypochondriacal ward in lunatic asylums. To view it without a guffaw is impossible.

(*D. G. Rossetti and Jane Morris, their correspondence*, ed. J. Bryson, Oxford, 1976, p. 174.)

25 Le Corbeau

The entire volume, lacking only the ex-libris. Number 64 of the edition of 240.
Provenance Sidney Colvin; presented by Dodgson.
1912-10-1-1 (1-4)
Reference G86; W95 and 97–100. The illustrations are on laid paper, and are inserted loose between the leaves of the book.

The British Library possesses another copy of the book (number 53), also printed on laid paper, which contains the ex-libris.

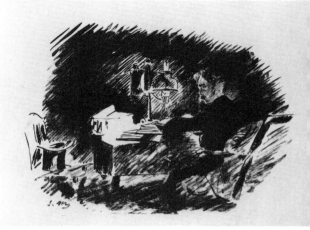

26

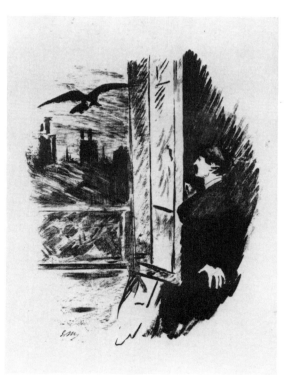

27

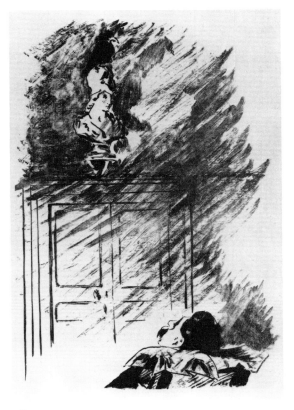

28

29

26–29 Le Corbeau

The four sheets of illustration.
One of the rare sets printed on China paper. The entire sheet measures 350 × 530 mm.
Provenance Purchased by Dodgson from Colnaghi's in 1912; Dodgson bequest. 1949-4-11-3330, 3332, 3331 and 3333 respectively.

26 PLATE 1 Sous la lampe
Reference G 86a; W 97

An illustration to the first verse of the poem:

> While I nodded, nearly napping, suddenly there came a tapping,
> As of some one gently rapping – rapping at my chamber door.
> ''Tis some visitor,' I muttered, 'Tapping at my chamber door –
>> Only this and nothing more.'

27 PLATE 2 A la fenêtre
Reference G 86c; W 98

28 PLATE 3 Le corbeau sur le buste
Reference G 86b; W 99

These two plates both illustrate the seventh verse:

> Open here I flung the shutter, when, with many a flirt and flutter,
> In there stepped a stately Raven of the saintly days of yore.
> Not the least obeisance made he; not an instant stopped or stayed he;
> But, with mien of lord and lady, perched above my chamber door –
> Perched upon a bust of Pallas just above my chamber door –
>> Perched and sat and nothing more.

29 PLATE 4 La chaise

Reference G 86d; W 100

This plate illustrates the final verse:

And the raven, never flitting, still is sitting – still is
sitting
On the pallid bust of Pallas just above my chamber
door;
And his eyes have all the seeming of a Demon's that is
dreaming,
And the lamp-light o'er him streaming throws his
shadow on the floor;
And my soul from out that shadow that lies floating on
the floor
 Shall be lifted – nevermore!

In the lithograph only the silhouettes of the raven and the author can be seen against the floor.

Odilon Redon

1840–1916

Born in the south of France to a wealthy father and a creole mother. His training as an artist was haphazard. The major influence was Bresdin, whose style he closely followed in various etchings of the 1860s (cf. 53); another important influence was the botanist Armand Clavaud (cf. 46). His independence as an artist dates from the 1870 Franco-Prussian war in which he was profoundly shaken by his experiences as a soldier. In the 1870s he began his series of *fusains* – black charcoal drawings; he took up lithography in the first place in 1879 at Fantin-Latour's suggestion merely as a means to reproduce these designs which he could not sell. The lithographs quickly became very popular, particularly in the Netherlands, and in the years to 1899 he made 164 of them, either in sets or individually. In the 1890s however his preferences moved towards colour, and after 1899 he dropped his *fusains* and lithographs in favour of oils and pastels.

Redon's work occupies a place apart in French art; although a friend of many of the symbolists, he did not himself subscribe to symbolist theories. His extraordinary compositions have lent themselves to numerous wild interpretations; Huysmans hung Redon's works in the rooms of his degenerate hero Des Esseintes in 1884, while in 1890 Arthur Symons called him a French William Blake. To counter these,

Redon supplied various explanatory texts to help his admirers, which were collected together in *A Soi-Même* of 1922. He always strongly insisted on his inspiration from and fidelity to nature:

Après un effort pour copier minutieusement un caillou, un brin d'herbe, une main, un profil ou toute autre chose de la vie vivante ou inorganique, je sens une ébullition mentale venir; j'ai alors besoin de créer, de me laisser aller à la représentation de l'imaginaire . . . De cette origine je crois mes inventions vraies.

He discouraged any definition: '*Mes dessins inspirent et ne se définissent pas. Ils déterminent rien. Ils nous placent, ainsi que la musique, dans le monde ambigu de l'indéterminé.*' Nor can his designs easily be seen as reflections of his personality; by contrast with Bresdin, his life was of extreme orthodoxy and absolute propriety.

The Department possesses, in addition to an extensive group of the lithographs, four *fusains* and a pastel.

Bibliography
M = A. Mellerio: *Odilon Redon*, Paris, 1913.
Lettres d'Odilon Redon, Paris, 1923.

30 L'Oeuf

1885
293 × 225 mm
Provenance Dodgson Bequest. 1949-4-11-3488
Reference M 60, first state.

This is an early state unknown to Mellerio; another impression belongs to the Art Institute of Chicago. In the later state there were numerous alterations: the table was cut at the right, the egg's left eye was blackened and a cluster of heads was introduced into the background.

According to Mellerio, this print was made for, but never included in, the album *Hommage à Goya*. Like the prints of the album it has no obvious, or indeed unobvious, connection with Goya. It is a very good example for Redon's statement: '*Toute mon originalité consiste à faire vivre humainement des êtres invraisemblables selon les lois du vraisemblable, commettant, autant que possible, la logique du visible au service de l'invisible.*'

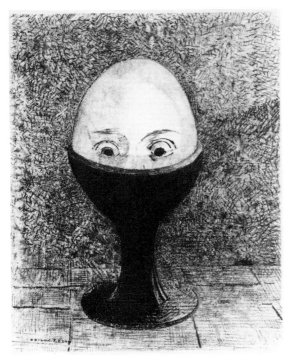

30

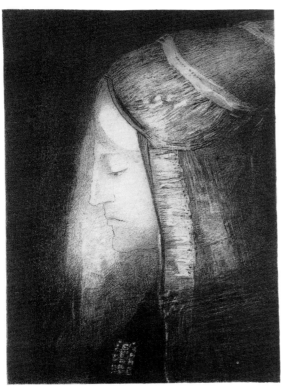

31

31 Profil de Lumière

1886
Chine appliqué. 340 × 242 mm
Provenance Presented by MM A. Sirouy and P. de
L'aage. 1888-6-19-156
Reference M61, from the edition of fifty.

This lithograph was made after a drawing now in the
Petit Palais, Paris, (illustrated by A. Mellerio: *Odilon
Redon*, Paris, 1923, opposite p. 36).

This impression comes from a collection of ninety-
eight contemporary French lithographs presented to
the Department in 1888 by MM Sirouy and de L'aage,
acting apparently as agents for the Société des Artistes
Lithographes Français. The collection included
twenty-six lithographs by Redon.

32 Araignée

1887
(see back cover)
Chine appliqué. 260 × 215 mm. Signed.
Provenance Presented by MM A. Sirouy and P. de
L'aage. 1888-6-19-153
Reference M72, second state with letters, from edition of
twenty-five.

The lithograph closely follows a charcoal drawing of
1881 (now in the Louvre). The drawing was described
by Huysmans in *A Rebours* in 1884, but was only
turned into a lithograph three years later. In another
drawing Redon made an even more alarming variation
on the theme; instead of the grin, large tears trickle
down the beast's face, (illustrated in the Exhibition
Catalogue, *Redon, Moreau, Bresdin* at the Museum of
Modern Art, New York, 1961, p. 57).

33–43 Tentation de Saint-Antoine

FIRST SERIES

1888
The set of frontispiece and ten plates. The plates are all on
chine appliqué.
Provenance A. E. Tebb; Dodgson Bequest.
1949-4-11-3492 to 3502 respectively
Reference M83 to 93

Flaubert's *Tentation de Saint-Antoine* was published in
1874. It was brought to Redon's attention by Emile
Hennequin in 1882; '*il me dit que je trouverais en ce livre
des monstres nouveaux*' (letter of 21 July 1898 to

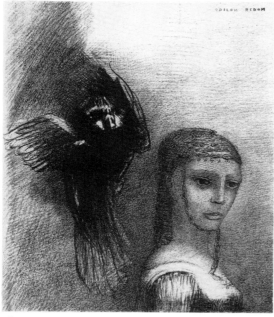

36

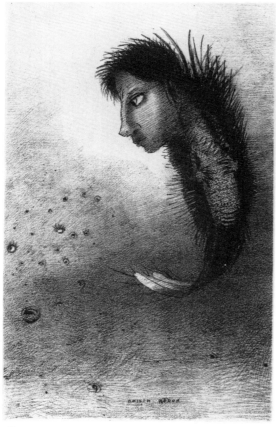

38

Mellerio). Not surprisingly the riotous exuberance of Flaubert's imagination appealed strongly to Redon, and he made not only this set (on commission from the publisher Deman of Brussels) but a second set in 1889 and a third set for Vollard in 1896.

The captions to the plates are directly quoted from Flaubert's text, and it will be seen how closely Redon has followed his words. Yet Redon always denied that he was an illustrator. (See J. Seznec: Odilon Redon and Literature, *French Nineteenth-Century Painting and Literature*, ed. U. Finke, Manchester, 1972.) Flaubert too hated the idea of illustrating his works; he objected to the way that the illustrator imposed a particular determinancy on everything: 'A drawn woman is just like one woman . . . instead a written woman makes you dream of a thousand women.' The peculiar success of these illustrations lies in the identity of approach between both artist and author. (See J. Seznec: Flaubert and the Graphic Arts, *Journal of the Warburg and Courtauld Institutes*, VIII, 1945, pp. 175 ff. This remarkable article also shows how Flaubert was often inspired by prints and drawings.)

33 COVER – FRONTISPIECE
198 × 140 mm
Reference M 83

The cover is signed by the artist.

34 PLATE 1
291 × 208 mm
Reference M 84

The inscription reads: . . . *d'abord une flaque d'eau, ensuite une prostituée, le coin d'un temple, une figure de soldat, un char avec deux chevaux blancs qui se cabrent.*

35 PLATE 2
254 × 200 mm
Reference M 85

The inscription reads: *C'est le diable, portant sous ses deux ailes les sept péchés capitaux.*

36 PLATE 3
190 × 160 mm
Reference M 86

This is a trial proof before letters. The inscription, in Redon's hand, reads: . . . *et un grand oiseau, qui descend du ciel, vient s'abbatre sur le sommet de sa chevelure.*

37 PLATE 4
274 × 196 mm
Reference M 87

The inscription reads: *Il hausse le vase d'airain*

38 PLATE 5
275 × 170 mm
Reference M 88

The inscription reads: *Ensuite, paraît un être singulier, ayant une tête d'homme sur un corps de poisson.*

39 PLATE 6
296 × 213 mm
Reference M 89

The inscription reads: *C'est une tête de mort, avec une couronne de roses. Elle domine un torse de femme d'une blancheur nacrée.*

40 PLATE 7
275 × 160 mm
Reference M 90

The inscription reads: . . . *la Chimère aux yeux verts, tournoie, aboie.*

41 PLATE 8
312 × 224 mm
Reference M 91

The inscription reads: *Et toutes sortes de bêtes effroyables surgissent.*

42 PLATE 9
204 × 158 mm
Reference M 92

This is a trial proof before letters. The inscription. in Redon's hand, reads: *Partout des prunelles flamboient.*

43 PLATE 10
282 × 230 mm
Reference M 93

The inscription reads: . . . *et dans le disque même du soleil, rayonne la face de Jésus-Christ.*

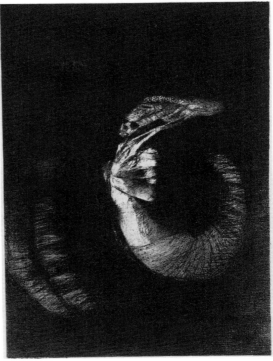

39

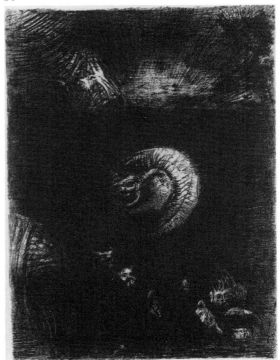

41

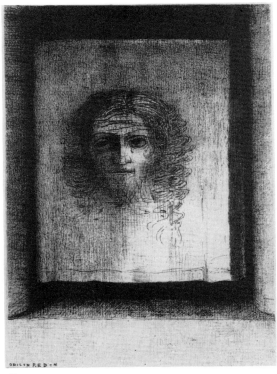

46

44 Pégase Captif

1888
Chine appliqué. 340 × 293 mm. Signed.
Provenance Presented by MM A. Sirouy and P. de
L'aage. 1888-6-19-154
Reference M 102, first state, one of the edition of 100.

The date of the acquisition of this impression (June 1888) shows that Mellerio's date for the print of 1889 must be wrong. Mellerio records a drawing of this subject. Some years after 1889 the stone was reworked and another edition of 100 printed.

45 Yeux clos

1890
Chine appliqué. 312 × 242 mm
Provenance Dodgson Bequest. 1949-4-11-3557
Reference M 107, from the first edition of fifty.

The lithograph follows very closely an oil-painting dated 1890, celebrated because it was the first work by Redon acquired by a French museum (in 1904, now in the Louvre).

In 1891 Edmond Picard, writing to Redon to thank him for the gift of this print, said that he recognized in the head the features of Mme Redon.

46–51 Songes

1891
The set of six plates. All are on chine appliqué.
Provenance Dodgson Bequest.
1949-4-11-3511, 3513-4, 3516-7, 3555 respectively
Reference M 110 to 115

The cover for the set (not exhibited, signed by the artist) has a dedication, *à la mémoire de mon ami Armand Clavaud.* Clavaud, who died in 1890, was a botanist whom Redon had known from his youth in Bordeaux. In a letter of July 1894 to a Belgian admirer, Bonger, Redon assessed Clavaud's importance to his work:

Ce que vous me dites à propos de la science est peut-être vrai. Ce qui est certain, c'est que j'ai eu vers les vingt ans et cultivé toute sa vie, un ami savant botaniste qui a dû avoir sur moi une influence probable. Son oeuvre était dans l'infiniment petit. Le microscope était toujours là, il faisait de la physiologie. Il se passionna à la recherche du mystérieux petit trait qui lie la vie végétale à la vie animale. Il le trouva. Ce fut un émoi chez les savants spéciaux. Avec cela, il était très artiste. Il s'était fait une bibliothèque où était le chef-d'oeuvre de toutes les littératures de chaque race. Il me parlait de Spinoza souvent et avec des larmes

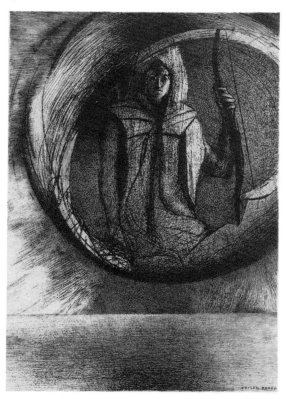

47

dans les yeux. Quand il est mort, il y a quelques ans, j'ai bien senti toute la place qu'il tenait en moi, au malaise que le vide m'a laissé. Je le voyais annuellement ici, et à chaque pas de la réflexion j'avais besoin de lui. C'était l'accord profond. Il était comme la tonique, assurément. Sans que je m'en doute, il a dû à certaines heures décisives avoir quelque influence sur moi.

The captions to the prints were supplied by Redon himself. He sent a copy of the album to Mallarmé who in reply said: '*Vous le savez, Redon, je jalouse vos légendes.*'

46 PLATE 1
188 × 133 mm
Reference M110

The inscription reads: . . . *c'était un viole, une EMPREINTE* . . .

47 PLATE 2
277 × 192 mm
Reference M111

The inscription reads: *et là-bas L'IDOLE ASTRALE, l'apothéose*

48 PLATE 3
208 × 275 mm
Reference M112

The inscription reads: *LUEUR PRÉCAIRE, une tête à l'infini suspendue*

49 PLATE 4
225 × 172 mm
Reference M113

The inscription reads: *Sous L'AILE D'OMBRE, l'être noir appliquait une active morsure* . . .

50 PLATE 5
275 × 205 mm
Reference M114

The inscription reads: *pélerin du MONDE SUBLUNAIRE*

51 PLATE 6
210 × 158 mm
Reference M115

The inscription reads: *LE JOUR*

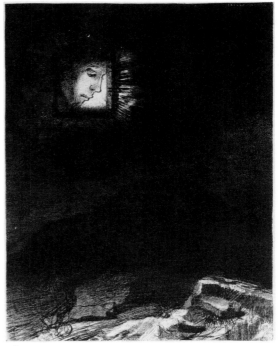

48

51

52 Parsifal

1892
Chine appliqué. 322 × 242 mm. Inscribed: *A Monsieur
A. E. Tebb*, and signed by the artist.
Provenance A. E. Tebb; Dodgson bequest.
1949-4-11-3518
Reference M 116

This and various other prints in the exhibition come from the collection of A. E. Tebb. He also owned three *fusains* and the famous pastel *Cellule d'Or* (mocked by Tolstoy in *What is Art?*); these were all bought from him by Dodgson in 1920 and were included in his bequest. Presumably Dodgson purchased the lithographs at the same time. Albert Edward Tebb qualified as a doctor in 1893 when he lived in Hampstead. In October 1895 he acted as host when Redon made a visit of eight days to London, (*Lettres d'Odilon Redon*, Paris, 1923, p. 25). In later life he became a specialist in tuberculosis; he died in or after 1941. His entry in the *Medical Directory* states that he was trained at Guy's, University College and in Paris, and it was presumably there that he met Redon. One would like to know more about Tebb; he is an interesting figure as he seems to be the earliest documented British collector of Redon.

Various passages in Redon's letters bear witness to his admiration for Wagner, (e.g. letter of 4 August 1898 to Fabre).

53 Le Liseur

1892
310 × 236 mm
Provenance Dodgson bequest. 1949-4-11-3521
Reference M 119

This impression has four diagonal lines across it, and was pulled after the stone had been cancelled. The tradition that this was intended to be, in some sense, a portrait of Bresdin is to be found in Mellerio's biography of 1923, page 31. Redon was Bresdin's pupil for several years in the 1860s; his reminiscences about him are reprinted in *A Soi-même*, pp. 156–162. Both artists admired Rembrandt enormously, and the derivation of the composition of this lithograph from Rembrandt must have been intended to be recognized.

54 L'Arbre

1892
Chine appliqué. 480 × 320 mm. Signed.
Provenance Dodgson bequest. 1949-4-11-3522
Reference M 120, first state before letters.

A passage in *A Soi-même* (p. 29) illuminates this image: '*Mais il y a dans la nature végétale, par exemple, des tendances secrètes et normales de la vie qu'un paysagiste sensitif ne saurait méconnaître: un tronc d'arbre, avec son caractère de force, lance ses rameaux selon des lois d'expansion et selon sa sève, qu'un artiste véritable doit sentir et représenter.*'

Redon made an almost identical drawing, (illustrated in the Museum of Modern Art Exhibition Catalogue of 1961, p. 27).

55 Lumière

1893
Chine appliqué. 392 × 272 mm. Signed.
Provenance Dodgson bequest. 1949-4-11-3523
Reference M 123, one of an edition of fifty (not twenty-five).

56 Mon Enfant

1893
Chine appliqué. 230 × 217 mm
Provenance Dodgson bequest. 1949-4-11-3524
Reference M 125

Redon's only child, Ari, was born in April 1889; this print shows him aged three, although, according to Mellerio, it was only made in 1893. Mellerio further says that this print was never put on the market, but was only given by the artist to his friends.

57 Cellule Auriculaire

1893
312 × 250 mm. Signed by the artist.
Provenance A. E. Tebb; Dodgson bequest. 1949-4-11-3525
Reference M 126, first state.

A pencil inscription at the bottom, signed A. E. T. (ebb), reads:

This copy was given to me by Redon – only one other example in this state exists – viz. the one in his own collection. About 2 inches was cut off the top of the stone before the copies (100) were struck off for 'L'Estampe Originale' – in which this & 'Bouddha' appeared. This plate has not been reprinted – but the

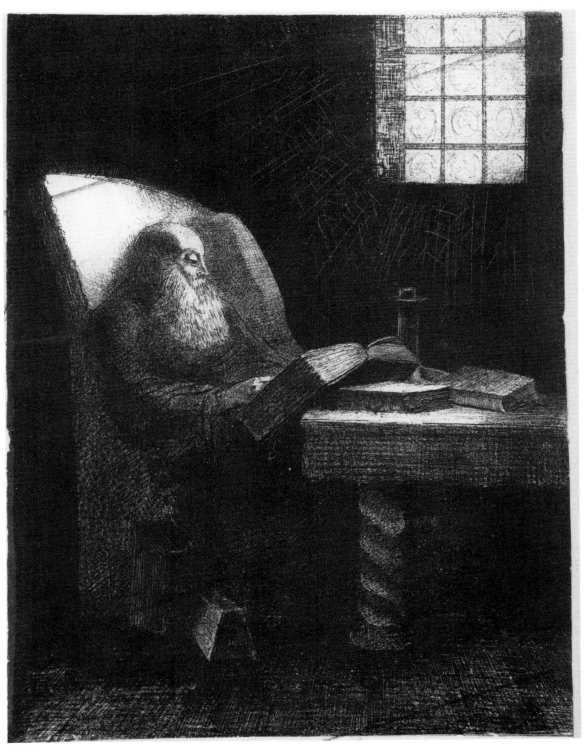

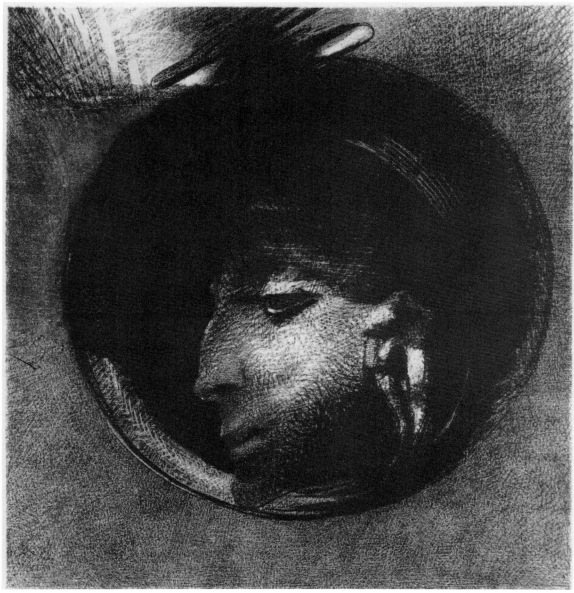

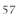

57

'Bouddha' has, and the stone has been reworked considerably since the earlier copies were printed.

The lithograph was published in the second album of *L'Estampe Originale* in the summer of 1893; thus Mellerio's date of 1894 is incorrect. This early state has apparently not yet been described.

58 Vieux Chevalier

1896
Chine appliqué. 298 × 239 mm. Initialled by the artist.
Provenance Purchased by Dodgson at Perl's auction, Berlin, November 1912; Dodgson bequest. 1949-4-11-3546
Reference M158, before letters.

This lithograph was commissioned and published by Vollard in his first *Album des Peintres-Graveurs* in July 1896, (cf. U. Johnson: *Ambrose Vollard Editeur*, 1977, cat. 101). Vollard also commissioned a colour lithograph for the second *Album* and published two sets of black and white lithographs, a *Tentation de Saint-Antoine* and an *Apocalypse*, in 1896 and 1899 respectively.

Camille Pissarro

1830–1903

Born in the West Indies. Educated in Paris, he returned to France permanently in 1855. In the 1860s strongly influenced by Corot; in 1874 exhibited at the first Impressionist exhibition, and remained one of the central figures of the movement.

Of the Impressionists, Pissarro was the most interested in printmaking. His most remarkable prints are certainly his etchings of which he made some 127 in the years after 1863. The first lithographs were a dozen made in 1874 (see 59). He then abandoned the medium and only made the other fifty-five between 1894 and 1898.

Pissarro's prints are rare; only eight were properly published in his lifetime, the others being printed in very small numbers for sale to a few collectors. As he explained to the astonished Vollard: *'Je ne fais pas des gravures que parce que cela m'amuse et que je ne tiens pas à les vendre.'* The majority of surviving impressions belongs to one of the posthumous editions printed by the artist's family, mainly in the 1920s when

Pissarro's prints first began to attract widespread attention. On the other hand Pissarro always took considerable care of his prints; he carefully annotated the state and number printed on each impression, and presented a complete collection to the Luxembourg Museum (now in the Bibliothèque Nationale).

Much information about the prints can be found in Pissarro's letters to his son Lucien, and in the article by Ludovic Rodo, another son.

Bibliography
D = L. Delteil: *Le Peintre-Graveur illustré*, XVII, Paris, 1923.
PV = L. R. Pissarro and L. Venturi: *Camille Pissarro – son art, son oeuvre*, Paris, 1939.
Letters = ed. J. Rewald: *Camille Pissarro, lettres à son fils Lucien*, Paris, 1950. (English translation, London, 1944)
L. Rodo: The etched and lithographed work of Camille Pissarro, *The Print Collector's Quarterly*, IX, 1922, pp. 275–301.

59 L'Oise à Pontoise

1874
On Japanese paper. 278 × 218 mm. Pencil lines have been drawn to frame the image.
Provenance Purchased at the Pissarro sale, 8 December 1928, lot 177, by Dodgson for 2,600 francs; Dodgson bequest. 1949-4-11-3364
Reference D132, the only known impression.

In 1874 Pissarro made a dozen lithographs on transfer paper. All are extremely rare, and this is the only one of the group in the Department. Nothing seems to be known about the circumstances of their manufacture. Pissarro had been in Pontoise since 1872.

60 Baigneuses à l'ombre des berges boisées

1894
Chine appliqué. 154 × 218 mm. Signed.
Provenance Presented by Charles Ricketts, Esq. 1920-10-18-6
Reference D142, second state. With the blindstamp of *L'Estampe Originale* (L819).

This lithograph was published in the ninth and last album of *L'Estampe Originale* in the spring of 1895. Pissarro had previously contributed an etching (D70) to the album of spring 1894. Marty, the editor, had first solicited a print from him in March 1893 (letter of 3 March 1893); in January 1894 this lithograph, already described as for Marty's last number, was being made (letters of 21 and 28 January 1894).

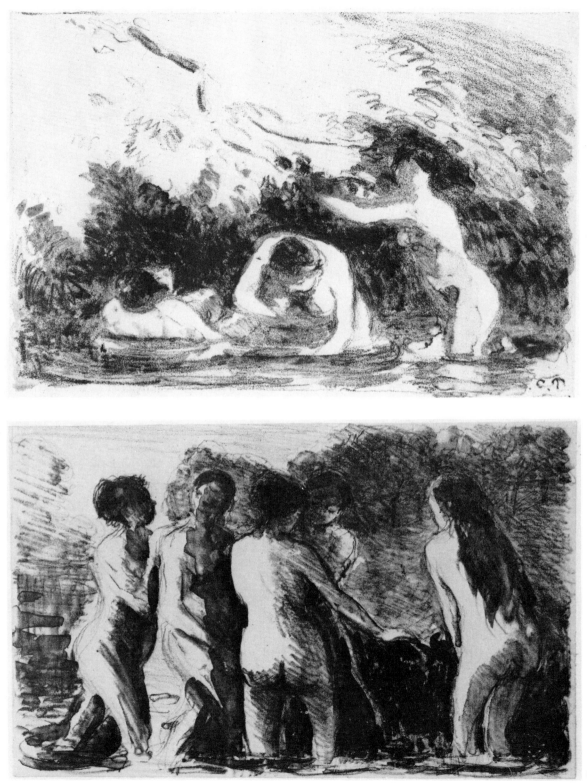

60

63

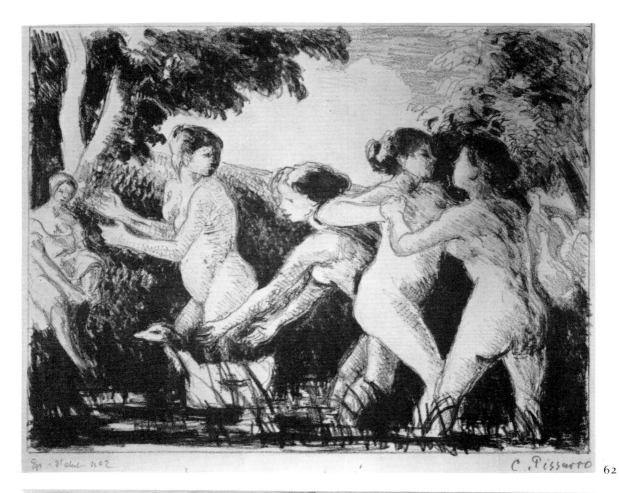

C. Pissarro 62

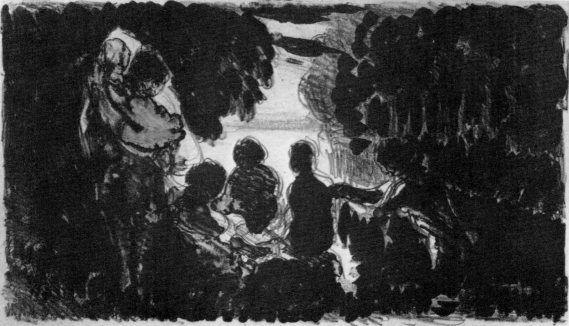

61

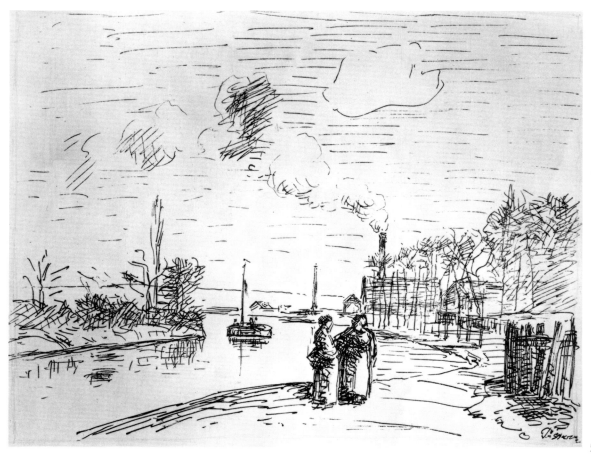

59

61 Baigneuses au bord d'un étang

1894
Chine appliqué. 237 × 142 mm
Provenance Presented by Charles Ricketts, Esq.
1920-10-18-4
Reference D 148, one of five or six known impressions.

In 1920 Ricketts presented to the Department one watercolour and five lithographs by Pissarro. The lithographs were all of *Baigneuses*. It is possible that some or all of them were given to him by Pissarro himself. Ricketts was a close friend of Lucien Pissarro in London, and in a letter of February 1891 Camille had offered him a gift of an etching.

62 Baigneuses luttant

1894
233 × 185 mm. Inscribed: *Ep. d'état no 2*, and titled and signed by the artist.
Provenance Purchased at the Pissarro sale, 8 December 1928, lot 204, by Dodgson for 1,400 francs. Dodgson bequest. 1949-4-11-3372
Reference D 159, first state, one of three impressions.

The changes made to this print in the succeeding two states were not very significant; the main alteration was to the profile of the second bather from the right. Pissarro repeated the same composition in reverse in another lithograph (D 160), and adapted it in an etching (D 118).

63 Théorie de baigneuses

1894
Chine appliqué. 130 × 203 mm. Inscribed on the verso, not in the hand of the artist, with the title and *no. 9*.
Provenance Presented by Charles Ricketts, Esq.
1920-10-18-5
Reference D 181, one of twenty impressions.

The group of four *Baigneuses* shown here is dated by Delteil from 1895–7. Stylistically however they seem to belong together, and in a letter of April 1894 Pissarro wrote: '*J'ai fait toute une série de dessins imprimés romantiques qui m'ont paru avoir un aspect assez amusant: des Baigneuses en quantité dans toutes espèces de poses, en des paysages paradisiaques.*' Since Delteil's date for the *Baigneuses à l'ombre des berges* is demonstrably wrong, it seems reasonable to date this whole group to the early months of 1894. It should however be borne in mind that the paintings of bathers continue to 1896, and that the lithographs probably do as well: thus D 158 is related to a painting of 1895, PV 937, while D 161 belongs with PV 941 of 1896 (and seems to be influenced by Cézanne, whose first exhibition in Paris opened in November 1895).

64 Marché à Pontoise

1895
Chine appliqué. 306 × 228 mm. Inscribed: *1er état no 1* and *Marché*.
Provenance: Purchased at the artist's sale, 8 December 1928, lot 190, by Dodgson for 3,300 francs; Dodgson bequest. 1949-4-11-3366
Reference D 147, first state, one of thirteen numbered impressions.

65 Marché à Pontoise

1895
Chine appliqué. 306 × 228 mm. Inscribed: *Ep. def. no 5* and signed and titled by the artist.
Provenance Dodgson bequest. 1949-4-11-3367
Reference D 147, third state, one of twenty numbered impressions.

In the second state the dress of the woman standing in the foreground was strengthened with lithographic wash. In the third state much was erased and redrawn in wash. This is the only lithograph for which an account of the artist's working procedure survives. In a letter of 8 April 1895 from Paris Pissarro wrote:

J'ai une grande litho sur pierre en train, un Marché. Je la travaille ici à Paris. Je l'ai tripotée avec du lavis, grattée, frottée au papier à l'emeri; je ne sais pas ce que cela donnera, mais j'ai été bête de faire un Marché, j'aurais dû faire des Baigneuses.

The composition of the lithograph is very close to that of a painting (PV 932) also dated 1895. This is wrongly catalogued as *Marché à Gisors*; the question is conclusively settled by the artist's autograph inscription on this impression. It is curious that Pissarro had left Pontoise for Eragny, near Gisors, as long before as 1884.

This has always been regarded as one of Pissarro's finest lithographs.

66 Bucheronnes

c. 1896
Chine appliqué. 130 × 103 mm. Inscribed: *No 3* and titled and signed by the artist.
Provenance Dodgson bequest. 1949-4-11-3373
Reference D 164, one of six impressions on chine.

66a Groupe de Paysannes

c. 1896
Chine appliqué. 132 × 112 mm. Inscribed: *No 4* and titled and signed by the artist.
Provenance Dodgson bequest. 1949-4-11-3374
Reference D 165, one of eleven impressions.

These two lithographs were drawn on the same zinc plate. When the plate was reprinted in 1923 both subjects were printed on a single sheet of paper.

67 Paysannes

c. 1896
Chine appliqué. 166 × 133 mm. Inscribed: *No. 7 sur chine* and titled and signed by the artist.
Provenance Dodgson bequest. 1949-4-11-3375
Reference D 166, one of eleven impressions.

The group of three studies of peasants shown here was clearly done at one time; all were published in editions of eleven.

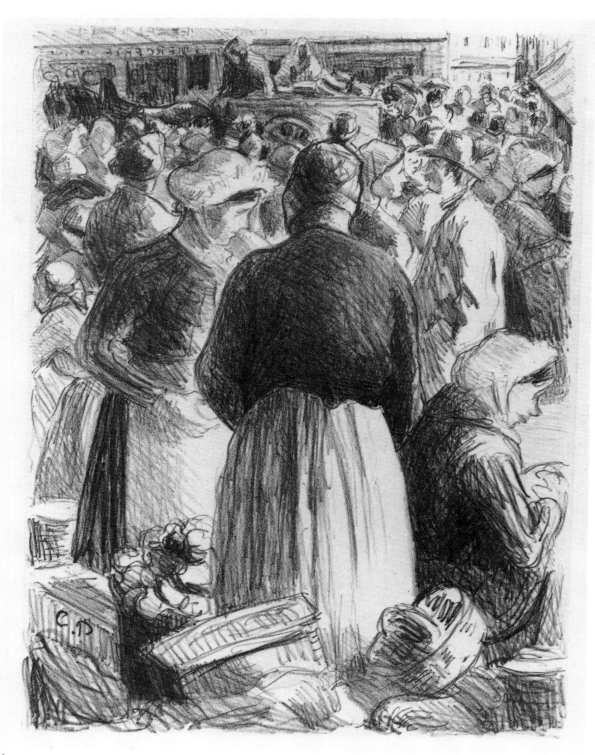

64

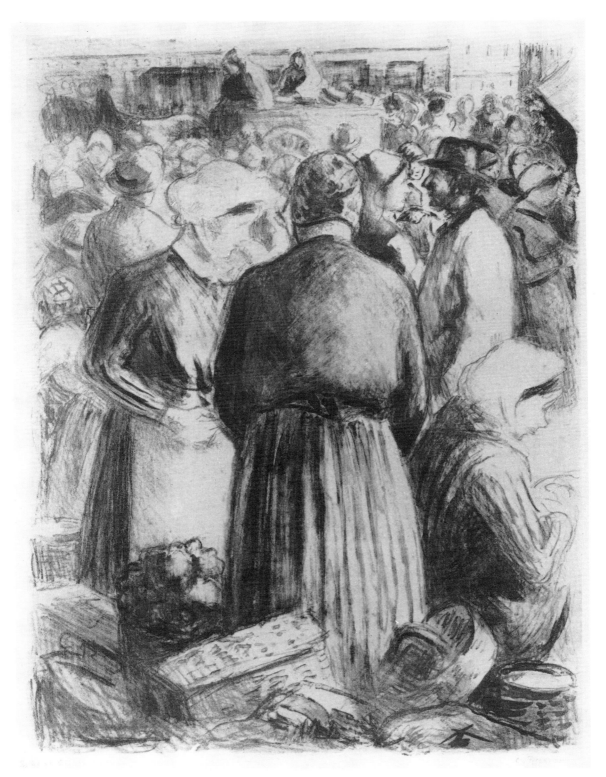

65

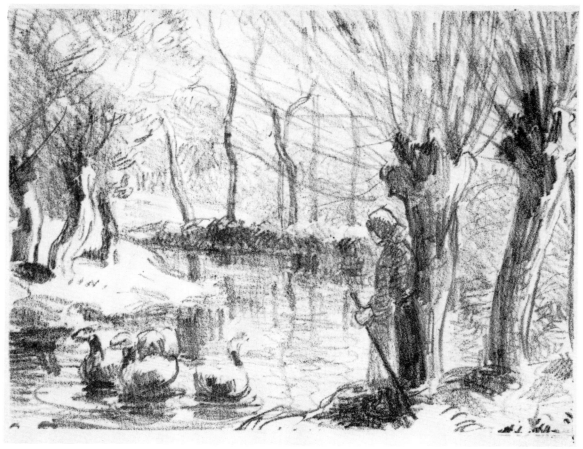

68

68 Gardeuse d'oies

c. 1896
130 × 168 mm. Inscribed: *No. 1* and titled and signed by
the artist.
Provenance Dodgson bequest. 1949-4-11-3381
Reference D187, one of the five or six trial proofs.

Although this print is dated by Delteil about 1898, it
seems to belong with the earlier group of peasant
women. The theme of the woman (whether clothed or
naked) watching over a flock of geese frequently recurs
in Pissarro's prints.

69 Rue Saint-Romain, à Rouen en 1896

On Ingres paper. 189 × 141 mm. Inscribed: *Ep. definitive
no. 8. 1ère série* and titled, signed and dated by the artist.
Provenance Dodgson bequest. 1949-4-11-3378
Reference D176, second state.

Pissarro worked in Rouen on several occasions in the
1890s. The work on the lithographs is described in a
letter of 6 February 1896:

*J'ai fait venir des plaques de zinc avec couche de calcaire
pour faire des lithographies de Rouen. J'ai commencé
quelques croquis de vieilles rues que l'on fait disparaître . . .
Si tu voyais la rue St. Romain, c'est épatant. J'espère que
.cela pourra avoir un certain intérêt.*

He made eleven lithographs in all of which four show
this same view of the rue Saint-Romain. The title and

date prove the topographical and archaeological purpose of the print; the *I^ère série* suggests that he was intending to make further studies.

Pissarro's love of old buildings could conflict with anarchist programmes. In 1902, after reading a pamphlet which attacked the restoration of medieval churches on the grounds that they were symbols of oppression, he wrote to Grave: *'Doit-on détruire les monuments gothiques, les chefs-d'oeuvre?? – Je ne le pense pas!'*

70 Pont Corneille, à Rouen

1896
Ingres paper appliqué. 300 × 217 mm. Inscribed: *I^er etat No. 2* and titled and signed by the artist.
Provenance Dodgson bequest. 1949-4-11-3377
Reference D 170, one of seven impressions on Ingres paper.

Pissarro in 1896 also made an etching of this subject (D 123) to which he gave the title *Quai de Paris à Rouen*. The hotel in which Pissarro stayed in Rouen was on the Quai de Paris, and from his window he could see

the harbour (letter 20 January 1896). At this period his eyes gave him much trouble; he could not work out of doors, but had to paint views from windows. The Ashmolean Museum in Oxford possesses a watercolour showing precisely the same view which proves that this lithograph is printed in the correct direction. In fact Pissarro here used transfer paper, as can be seen from the vertical flaw in the image right of the centre.

71 Rue Saint-Lazare, Paris

1897
Ingres paper appliqué. 211 × 143 mm. Inscribed: *Ep. def. no. 25*, and titled and signed by the artist, in purple ink.
Provenance Dodgson bequest. 1949-4-11-3379
Reference D 184, one of twenty-seven numbered impressions.

In 1897 Pissarro began his famous series of paintings of views of Paris. However, he only made two lithographs. The view here down the rue Saint-Lazare is seen in reverse, (cf. PV 981). Pissarro had already painted this scene in 1893 (PV 836).

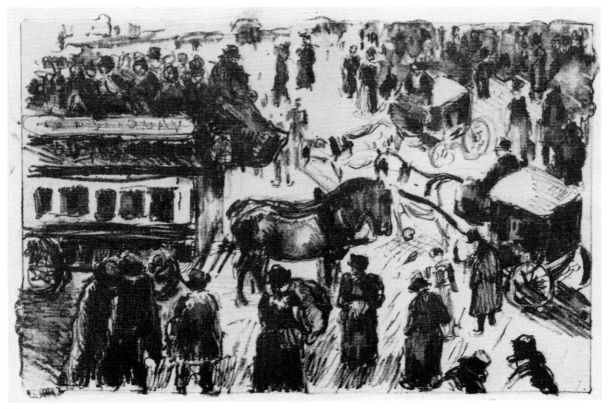

72

72 Place du Havre, à Paris

1897
Ingres paper appliqué. 144 × 213 mm. Inscribed: *Ep. def. no. 8*, and titled and signed by the artist, in purple ink.
Provenance Dodgson bequest. 1949-4-11-3380
Reference D185, second state, one of twelve impressions.

The scene here is set in the Place du Havre, at the top of the rue Saint-Lazare, just in front of the spot shown in the preceding lithograph, (cf. PV982).

73 La Charrue

1898
On simili-Japan paper. 215 × 151 mm. Inscribed: *Ep. d'essai no. 1*
Provenance Bequeathed by Hans Velten, Esq.
1931-7-21-72
Reference D194, first state, one of twelve trial proofs.

This lithograph is printed in three colours. The names of these are given in the printing controls in the lower right corner: *bleu de prusse, vermillon, jaune chrome*. In the later states these inscriptions were cleaned off. The twelve trial proofs are all said to differ since the artist was experimenting with different colours.

The lithograph was made as a frontispiece for *Les Temps Nouveaux*, a lecture by the anarchist Prince Kropotkin reprinted by Jean Grave in 1898. Grave was the most important French anarchist-communist, and was a friend of Pissarro from at least 1890. Pissarro, his sons and most of the Neo-Impressionists helped Grave in his various publications; Camille contributed two other lithographs in 1896 (D153, 154) and considerable sums of money. *La Charrue*, besides being used as a frontispiece, was also offered for sale by Grave as an individual print in 1909–11, in two editions, *édition ordinaire* at 2 francs, *édition d'amateur* at 3 francs 50 centimes. (Cf. R. L. and E. W. Herbert: Artists and Anarchism, *Burlington Magazine*, 1960, pp. 473 ff., 517 ff.)

This is Pissarro's only colour lithograph, and its exceptional nature is explained by the exceptional circumstances of its publication. Although Pissarro made various colour etchings, he disliked colour lithography (letter of 12 July 1896).

Edgar Degas

1834–1917

Born in Paris to wealthy parents. Trained in the tradition of Ingres; exhibited in all but one of the Impressionist exhibitions. From the early 1880s he was only partially sighted.

The basic catalogue of his prints, by Delteil, lists forty-five etchings and twenty lithographs. Degas' approach to printmaking was astonishingly original and highly experimental. He never regarded the print as a means to multiply a design; rather the print was a means to obtain effects unobtainable in any other way. Thus plates, both etched and lithographed, were continually reworked (one is known in twenty states) often by still unexplained processes, and only tiny numbers of impressions printed. Only one lithograph was published in Degas' life, and none became widely known until the sales of Degas' studio in 1918.

Bibliography
D = L. Delteil: *Le Peintre-Graveur Illustré*, XIX, Paris, 1919.
A = J. Adhémar, in: *Degas, the complete Etchings, Lithographs and Monotypes*, London, 1974.

74 Chanteuse de Café-Concert

c. 1878
252 × 192 mm
Provenance Degas sale (L657), (22 November 1918, one of lots 132–6); F. E. Bliss (L265); Dodgson bequest.
1949-4-11-3194
Reference D53, A33, first state.

Degas' lithographs were made in two periods. The first group belongs to the late 1870s, and is mainly concerned with subjects from the stage and theatre. In this print the singer seems to be performing on a stage with an awning above her head. The treatment of space however is deliberately ambiguous, as in many other prints of this period.

In the second state, the blank foreground is filled in with '*de travaux simulant plus spécialement des feuillages*'. This second state is even rarer than the first; one impression was sold in the Degas sale, but cannot now be located (W. M. Ittmann Jr.: *Lithographs by Edgar Degas*, Exhibition Catalogue, St. Louis, 1967, p. 15).

75 Femme nue debout à sa toilette

1891

Printed in bistre. 290 × 160 mm (image)
Provenance Degas sale (L657), (22 November 1918, lot 161, 1200 francs); Marcel Bing; Marcel Guérin (L1872b), (sale 23 March 1926, lot 26, £30 to Colnaghi); Dodgson bequest. 1949-4-11-3192
Reference D57, A62. One of two known impressions; the second, signed by the artist, is in the Cleveland Museum of Art, Ohio.

Degas' second group of lithographs was made as a single series in 1891. The exact date is documented in a letter of Pissarro of 25 April 1891: (Apropos of Degas) '*Il fait des lithographies; Meyer voudrait les avoir, c'est une affaire assez importante.*' However in a letter of 6 December 1891 Degas mentioned that he was hoping to do a series of lithographs of nude women at their toilet (*Degas Letters*, ed. M. Guérin, Oxford, 1947, p. 175), so the execution may have been delayed. Meyer was a small dealer; nothing seems to be known of this transaction which clearly was never completed as the lithographs were never published. In recent years a previously unknown collection of signed impressions from this series has been sold by the heirs of the dealer Pellet; perhaps he had acquired it from Meyer.

Six of the seven lithographs in the series show the same figure of a woman drying herself. There are three compositional variations, each of which is repeated in two lithographs. This and the following print is one such pair, the second type is shown in no. 77, while the third is represented by no. 78.

Unlike the previous exhibit, this lithograph was not drawn on the stone but was transferred. A very curious second transfer from what appears to be the same drawing is catalogued by Delteil as a soft-ground etching (D38, A undescribed); its present whereabouts are unknown.

In an exhibition held at the Galeries Petit in Paris in 1924, Marcel Guérin exhibited as item 218 a '*dessin à l'encre grasse sur celluloid, ayant servi à un report sur pierre que Degas a repris ensuite au crayon lithographique sur la pierre*'. This was used for D61, and provides the only firm evidence about how this series was made. Guérin had acquired the celluloid drawing from the Manzi sale; this supports other evidence from annotations on various impressions of the prints that the whole series was made in the atelier of Manzi, an expert printer. One advantage of using celluloid is that the design can be seen reversed, as it would be printed, by looking from the verso.

76 Femme nue debout à sa toilette

1891

310 × 200 mm (image)
Provenance Degas sale (L657), (22 November 1918, lot 163); Marcel Guérin (L1872b), (sale 9 December 1921, lot 110, ? brought in), (sale 23 March 1926, lot 27, £39 to Colnaghi); Dodgson bequest. 1949-4-11-3193
Reference D65, second state; A63, presumably fourth state.

The Museum's impression of the second state appears to be unique, and has never been illustrated. This has allowed various inaccuracies to creep into the listing of the states of this print, which it might be worth correcting. Delteil's order is correct so far as it goes. The first state (unique impression in the Fondation Doucet, University of Paris: illustrated in *L'Estampe Impressionniste*, Exhibition Catalogue, Bibliothèque Nationale, Paris, 1974, p. 92, no. 201) was transferred from a drawing. In the second state, exhibited here, the stone was reworked directly by brush with lithographic ink. The new work on the hair, round the shoulders and buttocks and between the legs can easily be distinguished by its congealed and blobby nature. Parts have been reworked with a scraper and roulette. In the third state the composition was extended at the left and the top, and the model's hair drawn in with ink washes, (illustrated in *L'Estampe Impressionniste*, no. 202). In the fourth state the hair was reworked with a scraper and lightened (illustrated by Delteil). E. W. Kornfeld has discovered a new fifth state in which the ink washes are getting very worn, and the left extension of the composition is eliminated, (illustrated by E. W. Kornfeld: *Edgar Degas, Beilage zum Verzeichnis des Graphischen Werkes von Loys Delteil*, Bern, 1965, as the fourth state). One must however admit a difficulty over the hair in the fifth state which seems to be closer to the third than the fourth state. Without comparing impressions no certainty is possible; but perhaps either Degas redrew the hair in the fifth state, or the order here given of the third and fourth states ought to be reversed.

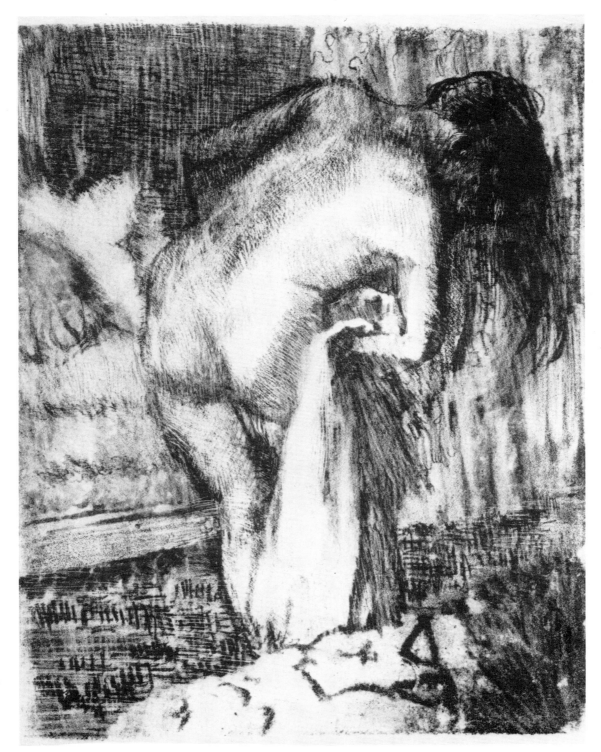

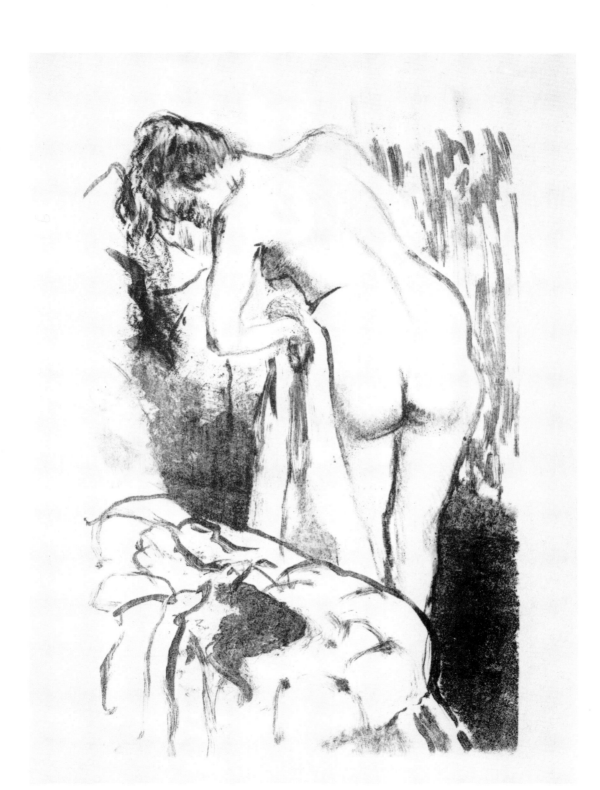

77 Après le bain

1891
190 × 147 mm (image); 238 × 185 mm (platemark)
Provenance Degas sale (L657), (22 November 1918,
lot 155); presented by the Contemporary Art Society.
1925-3-14-53
Reference D60; A64, fifth state.

This print went through five states. It began as a
straightforward transfer of a drawing; then the image
was reworked on the stone. In this fifth state the head
and left shoulder were redrawn about a centimetre
higher, and the vertical hatchings added to the carpet
on which the model stands. There is a further sixth
state where the design is thought to have been
transferred to another stone. All the states are only
known in unique impressions.

78 La sortie du bain

1891
Drawing in pencil over a lithograph. 350 × 328 mm
Provenance Third Degas sale (L658), (7–9 April 1919,
lot 334); presented by the Contemporary Art Society.
1925-3-14-1

This has always been described as a drawing, but,
under examination in the Conservation department,
has proven to be drawn on top of a lithograph. The
third type of the woman drying herself (cf. 75) has
hitherto been known in two lithographed versions
(D63 and 64). The underlying lithograph here can be
identified with neither of these, and is therefore a
previously unknown third variant.

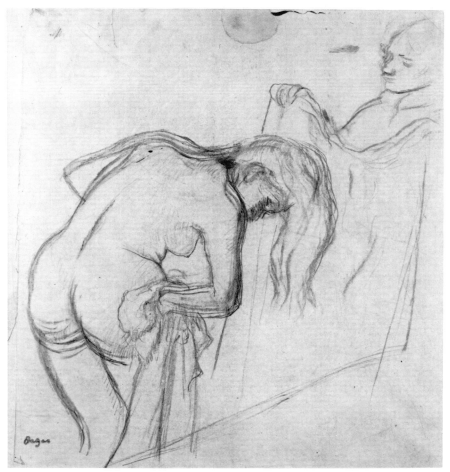

78

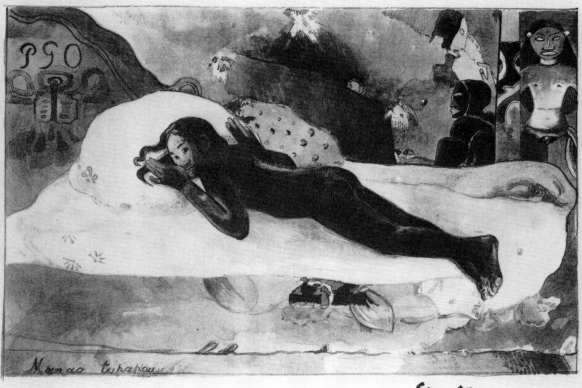

Menao tupapau

Ep. 27.
Paul Gauguin

Paul Gauguin

1848–1903

Originally a stockbroker and amateur painter; from 1883 a professional artist. Based in Paris and Brittany 1886–90; travelled to Martinique in 1887. Lived in Tahiti 1891–3 and again from 1895 until his death.

Gauguin only made some fourteen lithographs, and the medium does not seem to have greatly interested him. His woodcuts are by comparison much more exciting and extremely original; thirty-six of these are known, half made in Paris in 1893–5, and half in Tahiti in 1895–1903.

Bibliography
G = M. Guérin: *L'Oeuvre Gravé de Gauguin*, Paris, 1927.
W = G. Wildenstein: *Gauguin*, Vol. I, Paris, 1964.

79 Joies de Bretagne

1889
On simili-Japan. 200 × 222 mm
Provenance Dodgson bequest. 1949-4-11-3265
Reference G 2, second edition.

This and the following print belong to a series of ten zincographs (that is lithographs drawn on zinc) and a cover made in 1889. It was printed by Ancourt in an edition of some thirty to fifty impressions, and was advertised for sale at 20 francs in the catalogue of the exhibition of the *Groupe Impressionniste et Synthétiste* at the Café Volpini in 1889. This first edition was printed on a wove paper of a very strong yellow colour. Later

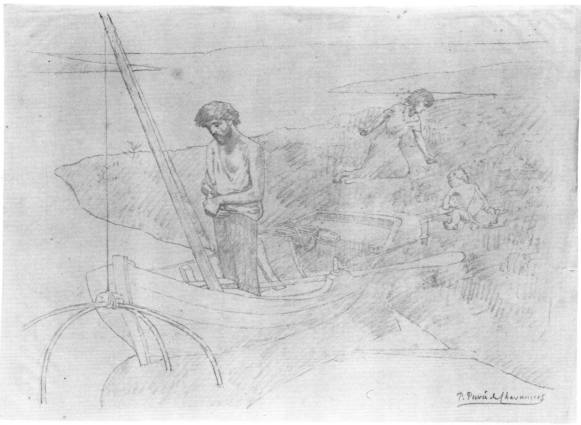

83

Vollard, who acted as Gauguin's agent while he was in the Pacific, came into possession of the plates and reprinted them on a greatly inferior imitation Japan paper of a similar yellow.

The subjects of the lithographs were drawn from Brittany and Martinique. The same subject as in this print, but in a different composition, recurs in a painting of 1889 (W 350).

80 Les Cigales et les Fourmis

1889
On simili-Japan. 200 × 262 mm
Provenance Dodgson bequest. 1949-4-11-3266
Reference G 10, second edition.

This print belongs to the same series as the preceding item. The title, *The Cicadas and the Ants*, is enigmatic and apparently unexplained. The print was given a subtitle: *Souvenir de Martinique*.

81 Manao Tupapau

1894
180 × 271 mm. Signed by the artist in purple ink and numbered *Ep. 27*.
Provenance Dodgson bequest. 1949-4-11-3268
Reference G 50, with the blindstamp of *L'Estampe Originale* (L 819), from the edition of 100.

Gauguin returned from Tahiti in September 1893; in the following months he made two lithographs both for publication. The earlier was this print which was published by Marty in the sixth album of *L'Estampe Originale* in the early summer of 1894.

The print reproduces in reverse, with considerable alterations, the painting (W 457) of 1892. The title was translated by Gauguin in a letter as '*Elle pense au revenant, ou, l'esprit des morts veille*'. The image is a record of an occasion when he returned home in the early hours to find his thirteen-year-old Tahitian mistress Tehamana terrified by the image at the foot of

the bed which she took for a ghost. Gauguin thought the painting one of his finest works and set a very high price on it. This is obviously the reason why he chose this as the subject for Marty's commission.

82 Ia Orana Maria

1894
On white wove paper. 257 × 179 mm
Provenance Dodgson bequest. 1949-4-11-3267
Reference G 51

Guérin's description of this print is inadequate; this Department possesses a second impression (1942-3-7-1) on simili-Japan, but neither is signed or numbered, and neither has the blindstamp of *L'Épreuve* (L 2783). The lithograph was published as number 33 in *L'Épreuve* of March 1895. *L'Épreuve* was an obscure rival of *L'Estampe Originale*; it appeared in twelve monthly instalments of ten prints and four pages of text from December 1894. The total edition was 215.

The title is the opening of the Tahitian translation of the *Ave Maria*. The composition is an adaptation, in reverse, of the central group of the Virgin and Child (both with haloes) in the painting of 1891 (W 428). Gauguin repeated the design in several drawings and monotypes.

The circular stamp in the bottom left corner comes from Gauguin's woodcut seal; a direct impression from this is on a monotype in the Department's possession (1949-4-11-3675).

Pierre Puvis de Chavannes

1824-98

Born in Lyons; his father was an engineer and supported him throughout his life. First exhibited at the Salon of 1850. His idealist compositions lent themselves to large-scale decorative schemes, and most of his works are still in the rooms for which they were painted. Only in the last decade of his life did he win widespread public acceptance and the admiration of other artists.

Puvis, although a disappointing painter, was a sensitive draughtsman. It is therefore perhaps surprising and significant that he seems to have made

no lithographs before he was commissioned to do so by the publishers of the 1890s. His seven original prints are discussed in an article by Douglas Druick: *Nouvelles de l'Estampe*, nos. 34/5, 1977, pp. 27-35.

83 Le Pauvre Pêcheur

1897
410 × 525 mm
Provenance Purchased from M. Sagot for £3.
1913-6-17-9
Reference U. Johnson: *Ambrose Vollard Editeur*, New York, 1977, cat. 98.

This lithograph was published by Vollard in 1897 in the second *Album des Peintres-Graveurs*. For Vollard's commission Puvis chose to do a version of *Le Pauvre Pêcheur*. This had been painted in 1881 and exhibited at the Salon of that year; re-exhibited by Durand-Ruel in 1887 it was acquired by the Musée du Luxembourg and thus became the artist's best known painting. In all important respects the lithograph corresponds closely to the painting. Since both are in the same direction, it was almost certainly drawn on transfer paper.

In *Là Lithographie Originale en Couleurs*, Mellerio mentions this print '*à titre de curiosité*' – which seems fair enough.

Paul Cézanne

1839-1906

Born in Aix-en-Provence. In 1861 began to study painting in Paris. In 1874 and 1877 exhibited with the Impressionists, but thereafter spent most of his time in retirement in the south, until discovered by Vollard who arranged an epoch-making exhibition of his work in 1895.

Only eight prints by him are known. Five are etchings, which were made while staying with Dr Gachet in 1873. The other three are lithographs and were all made for Vollard in 1896-7.

Bibliography
C = J. Cherpin: *L'Oeuvre gravé de Cézanne*, Marseilles, 1972.

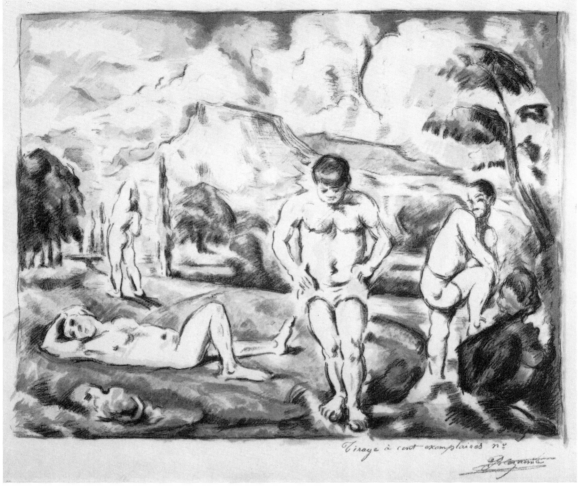

84

84 Les Baigneurs (grande planche)

1896–7
Four colours. 410 × 503 mm
Provenance Dodgson bequest. 1949-4-11-3189
Reference C 7, with the printed signature and *justification de tirage*.

This lithograph has been thoroughly investigated in an outstanding article by Douglas Druick (*Bulletin of the National Gallery of Canada*, XIX, 1972, pp. 2–24). Vollard commissioned it, along with a self-portrait, from Cézanne for a projected third *Album des Peintres-Graveurs* which was never published. It follows closely a painting of 1875–6 now in the Barnes Foundation in Merion, Pennsylvania. As in the case of Puvis de Chavannes, this painting was chosen for reproduction since it was the artist's work best known to the public. It had been shown in the Impressionist exhibition of 1877 and had been lavishly praised by various critics. Cézanne drew the design on transfer paper. He then coloured in watercolour impressions of the design printed in black (three are known at present), and these served as Clot's guide in the preparation of the three colour stones. Druick distinguishes two editions printed from two different sets of stones and with very different colours. The editions can be distinguished by the presence or absence of the printed signature.

Alfred Sisley

1839–99

Born in France of English descent. First exhibited at the Salon in 1866, but joined the Impressionists in their exhibition of 1874. Less fortunate than Monet or even Pissarro, he only began to achieve a modest success in the very last years of his life. Sisley only made four etchings in 1890, and two lithographs in 1896–7.

Bibliography D = L. Delteil: *Le Peintre-Graveur illustré*, XVII, Paris, 1923.

85 Bord de Rivière, ou, Les Oies

1897
Six colours on paper appliqué. 215 × 318 mm. Signed and numbered 11.
Provenance Dodgson bequest. 1949-4-11-3408
Reference D 6, from an edition of 100.

This lithograph was commissioned and published by Vollard in his second album in 1897. It was discussed, together with a lithograph by Rodin in the same album, by Mellerio in *La Lithographie Originale en Couleurs* of 1898. A propos of the Rodin he stated:

C'est le triomphe du fac-simile. Au point de vue de l'estampe, moins une oeuvre originale qu'une restitution chromolithographique excessivement adroit due à l'imprimeur Clot . . . À la même catégorie appartient une lithographie en couleurs, véritable tour de force de métier, exécuté toujours par Clot, d'après un pastel clair et lumineux de Sisley.

From the appearance of the print Mellerio appears to be absolutely accurate.

Pierre Auguste Renoir

1841–1919

Began as a painter on china. Exhibited in most of the Impressionist exhibitions. In the 1880s he moved away from Impressionism, strongly influenced in this by several visits to Italy. In the 1890s he made some fifty prints, about half being etchings and half lithographs. Despite this substantial production, it is difficult to feel that he was really very interested in printmaking.

Bibliography
D = L. Delteil: *Le Peintre-Graveur illustré*, XVII, Paris, 1923.

86 Le Chapeau Epinglé

1898
Eleven colours. 600 × 488 mm
Provenance Presented by Dodgson. 1927-7-12-12
Reference D 30

The models in this composition were Berthe Morisot's daughter and her cousin Paulette Gobillard. Renoir first made a pastel and an oil of them in 1893. In 1894 he repeated the composition in an etching (D 8), and in 1897–8 used it again in two lithographs commissioned by Vollard. The first (D 29) was only published in sanguine, bistre or black; the second was published in colours as well. It is one of four lithographs made by Renoir around 1898 in close collaboration with the printer Auguste Clot.

This print is discussed by Roger Passeron in his book: *Impressionist Prints*, London, 1974, pp. 124–6. He states that Renoir made the drawing on transfer paper, and reworked the image on the stone with lithographic ink. In this state the print was printed and published in black, sanguine, bistre, mauve or blue. Renoir then coloured in pastel one of these impressions, which Clot then used as his guide to prepare the colour stones. Passeron distinguishes two editions printed in colour; the second edition, to which our impression belongs, has extra colours added. The history of this print thus matches exactly that which Druick has traced for Cézanne's *Baigneurs*, (see 84).

Jules Chéret

1836–1932

Chéret was trained in lithographic printing techniques in London between 1859 and 1866. On his return to Paris his technical and business skill allied with his flair for design ensured his total domination of the poster until Toulouse-Lautrec's appearance in 1891. He made no posters after 1900. Maindron catalogues no fewer than 882 designs he made before 1896; this was only possible with the assistance of a large team at the printing-house which Chéret himself owned.

Bibliography M = E. Maindron: *Les Affiches Illustrées*, Paris, 1896, pp. 193–242.

87 Eldorado: Music Hall

1894
1180 × 820 mm. With a 20 centime ensus stamp.
Provenance Presented by E. H. Blakesley, Esq.
1929-6-11-75
Reference M189

This is one of Chéret's most famous posters, made for an obscure music hall of the Boulevard Strasbourg. Chéret also made two reduced replicas of this design. His method of designing posters with wildly gesticulating figures in undefined spaces hardly varied, and this one may be taken as typical of all. Chéret's female figures were in fact soon christened 'Chérettes'.

Henri de Toulouse-Lautrec

1864–1901

Descended from an ancient aristocratic family; his full title was vicomte de Toulouse-Lautrec-Monfa. As a result of two accidents to his legs in childhood, he only reached four-and-a-half feet. In 1882 began to study painting in Cormon's studio in Paris, where Van Gogh was a fellow pupil. In 1884 established his own studio in Montmartre, where the theatres, dance halls and brothels dominated his life. In 1899 he took a cure for alcoholism, but finally collapsed and died in 1901.

Lautrec began as a painter, influenced principally by Degas, whom he idolized, and Japanese prints. Between 1888 and 1891 he attracted the attention of the critics Octave Mirbeau, Arsène Alexandre and Roger Marx, who were to act as propagandists for his work throughout the ensuing decade. 1891 was the critical year for his development as a lithographer, since it marked the commission of his first colour lithograph, a poster *La Goulue* (see 88) for the Moulin Rouge, whose director had purchased one of his paintings the year before. The poster won Lautrec instant recognition; he rapidly perceived the expressive possibilities offered by colour lithography, and in Mellerio's book of 1898 was acclaimed as the foremost exponent of the medium. Mellerio even ventured the opinion that his lithographs were superior to his oils, and many will have little hesitation in agreeing with him. For Lautrec the lithograph was no minor art form, but was treated quite as seriously as his painting. Between 1891 and 1901 he produced 357 litho-

graphs, including song sheets, posters and an increasing number of single sheet prints for collectors, a market of which he was keenly aware. By 1895 his prints had achieved sufficient renown to warrant two exhibitions in London, in 1896 a lithograph was commissioned from America (see 133), and in 1900 he was appointed to the select committee for the Exposition Universelle to commemorate the centennial of lithography.

Lautrec had total mastery of lithographic technique. His prints were always made in the lithographic workshops in the closest collaboration with the craftsmen. He normally used the Ancourt establishment, where he worked in particular with Père Cotelle, an extremely old and highly experienced printer.

Dortu's superb catalogue of Lautrec's paintings and drawings shows that there are very large numbers of these related to the lithographs. No attempt is made here to refer to them. The dating and descriptions of states for the prints follow Adriani.

Bibliography
D = L. Delteil: *Le Peintre-Graveur illustré*, x and xi, Paris, 1920.
A = G. Adriani: *Toulouse-Lautrec, das gesamte graphische Werk*, Cologne, 1976 (the catalogue is compiled with the assistance of W. Wittrock).
Dortu = M. G. Dortu: *Toulouse-Lautrec et son Oeuvre*, 6 vols, New York, 1971.
Joyant 1926 = M. Joyant: *Henri de Toulouse-Lautrec, peintre*, Paris, 1926.
Joyant 1927 = M. Joyant: *Henri de Toulouse-Lautrec, dessins, estampes, affiches*, Paris, 1927.
Letters = *Unpublished Correspondence of Henri de Toulouse-Lautrec*, ed. L. Goldschmidt, London, 1969.

88 Moulin-Rouge (La Goulue)

1891
Four colours. 1655 × 1150 mm. With the ensus stamp.
Provenance Purchased from Mme Barthelemy.
1921-6-14-18
Reference D339; A1, second state, before additional lettering.

This poster was printed in three sections. In this impression the topmost part is lacking, which explains why the lettering is cut off half-way through 'Bal'. This poster is Lautrec's first lithograph; a print (D10) which Delteil dated to 1885 has been shown to be only a reproduction of a drawing (cf. F. Lachenal: *Toulouse-Lautrec*, Exhibition Catalogue, Ingelheim-am-Rhein,

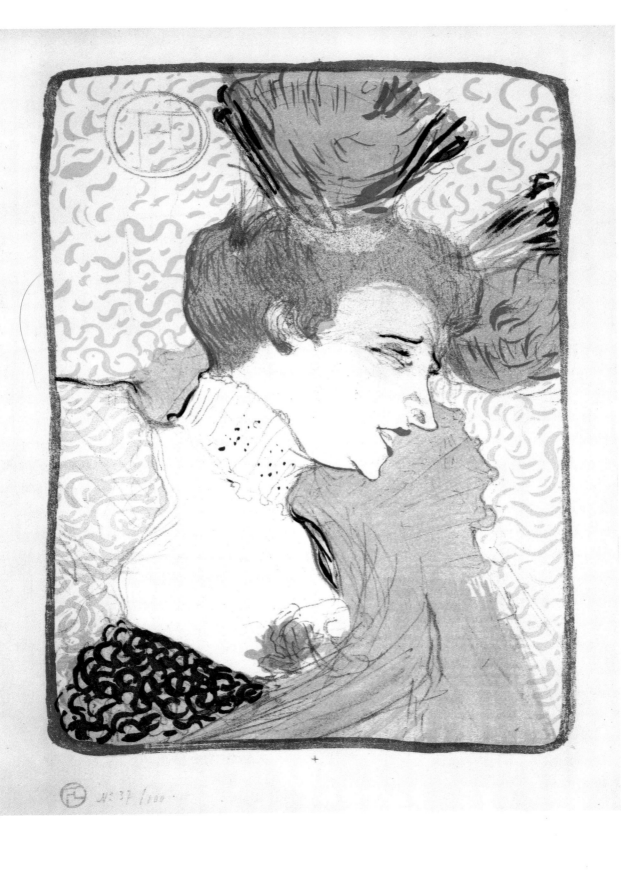

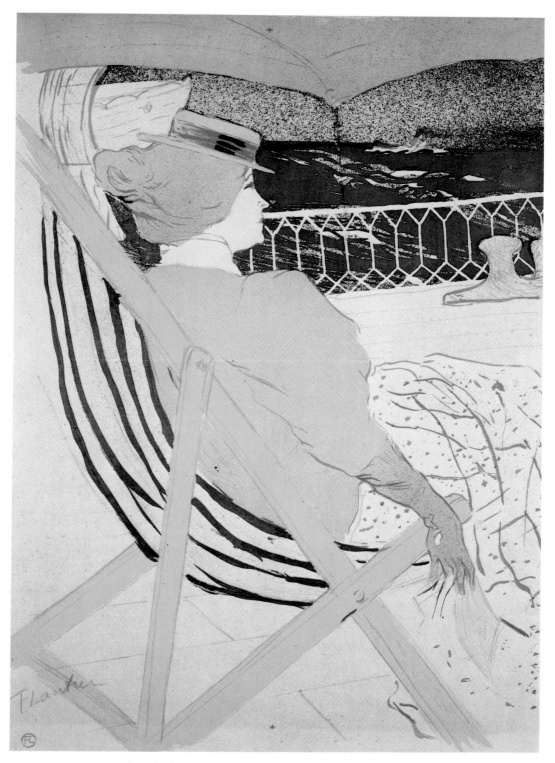

116 Toulouse-Lautrec *La Passagère du 54*

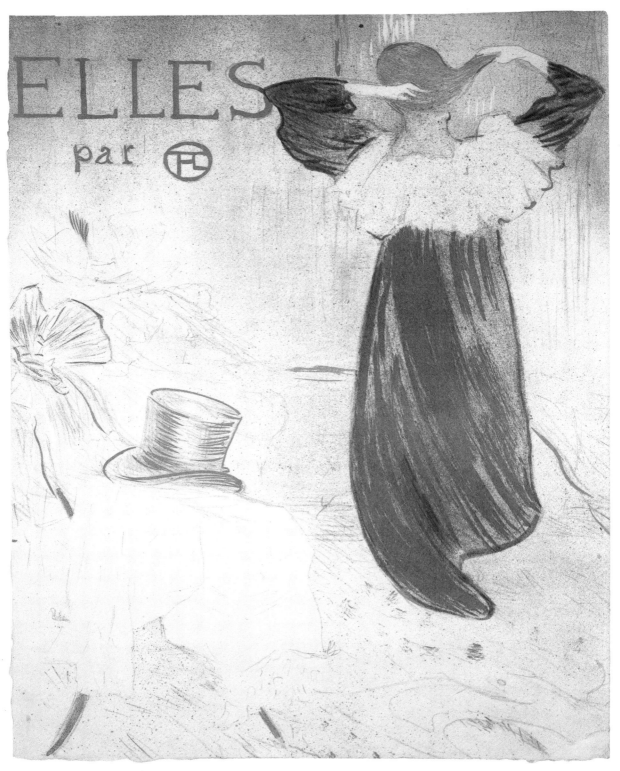

120 Toulouse-Lautrec *Elles: frontispiece*

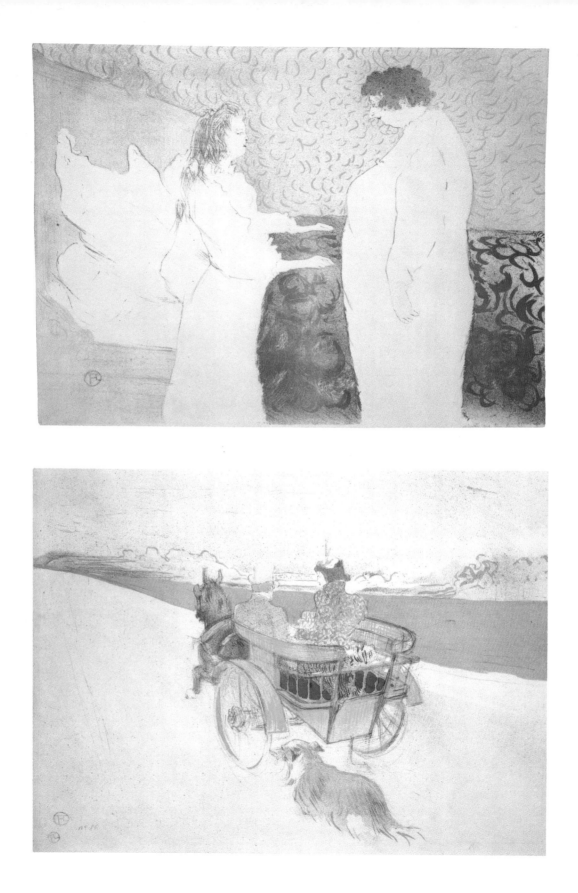

1968). 'La Goulue' (the glutton) was the nickname of the dancer Louise Wéber; her partner, the man silhouetted in the foreground, was Jacques Renaudin, alias Valentin le Désossé (the disjointed).

The Moulin Rouge first opened in October 1889, and Chéret had in that year made a famous poster for it. By 1891 its fortunes were waning, and so Zidler, the proprietor, hired a galaxy of talent from the other dance halls of Paris (including La Goulue from the Elysée-Montmartre) and commissioned a new poster from Lautrec (Joyant 1926, p. 136). The famous photograph of Zidler's assistant Tremolada and Lautrec, hat in hand in mock homage, in front of Chéret's poster was taken on this occasion. *Moulin-Rouge* went up in October and overnight established his reputation with a wide public. To a generation used to Chéret, Lautrec's design was totally original. It is moreover the largest of the thirty posters he made, and is an astonishing achievement for someone who had never made a lithograph, much less a poster, before.

89 Miss Loie Fuller

1893
Printed from several plates with hand colouring.
370 × 260 mm. Signed by the artist and inscribed *Passe*.
Provenance Purchased. 1977-11-5-14
Reference D 39; A 8, a proof before the edition of fifty.

This print is quite exceptional in Lautrec's oeuvre. According to Delteil, who obtained his information from André Marty, the publisher of the print, the lithograph was only printed in black. Each impression was then hand coloured by Lautrec himself, with a final heightening of gold or silver powder (the last idea obviously being borrowed from Japanese prints). This account however cannot be correct. Decisive evidence is supplied by an impression (sold Paris, Galerie Charpentier, 2 June 1959, lot 31, ill.) where only the base stone was printed; in this the design only extends about a centimetre to the side and above the dancer, while the drapery is entirely blank. This proves that at least two stones were employed, and indeed a further impression recently sold (Sotheby's, 4 October 1977, lot 279, ill.) had the clear signs of three different plate marks. Further, from a comparison of several impressions, it appears that the colours in which it was printed vary, quite apart from the differences in the hand colouring applied later.

Our impression has added interest in being an '*épreuve de passe*' – that is the artist's declaration that he is satisfied with the quality of impression before any edition is run off. Joyant (1927, p. 89) emphasizes that Lautrec '*détruisait impitoyablement les épreuves de passe*' and asserts that very few of them could have escaped into circulation.

Loie Fuller came from America; she began dancing at the Folies-Bergère in October 1892 and caused a sensation. Delteil reprints a remarkable description of her act. She came on stage swathed in a mass of drapery which she swirled around her in a succession of patterns. The only illumination came from coloured electric spot-lights which played on the falling drapery in a kaleidoscope of colours. It must have been this effect of shifting colour which Lautrec was trying to capture by colouring each impression differently.

This print seems to have been published in February 1893 and is the earliest colour lithograph made by Lautrec which is not a poster. In a sense therefore it can be said to stand at the head of the colour revival of the 1890s. It has further interest for the history of Art Nouveau since Loie Fuller's dance inspired many artists (including Chéret and Larche) and has been regarded as one of the sources of the style.

90 Divan Japonais

1893
Four colours. 810 × 605 mm. With a blue stamp: *Affiches pour collections A. Arnould, Rue Racine, Paris.*
Provenance Presented by E. H. Blakesley, Esq.
1929-6-11-71
Reference D 341; A 9

Jane Avril is in the foreground accompanied by the critic Edouard Dujardin. Yvette Guilbert, who can be recognized by her long black gloves, is singing on the stage. The Divan Japonais in the rue des Martyres was one of the less successful Parisian night spots. This poster was published in January 1893 but before July it had closed. Lautrec's posters were immediately acclaimed by the critics. In *La Justice* of 15 February 1893, Gustave Geffroy wrote: '*Bruant, La Goulue et plus récemment le Divan Japonais ont pris possession de la rue avec une autorité irrésistible. Il est impossible de ne pas voir l'ampleur des lignes et le sens artistique des belles taches.*'

89

91 Jane Avril: Jardin de Paris

1893
Five colours. 1225 × 880 mm. With a blue stamp: *Affiches pour collections A. Arnould, Rue Racine, Paris.*
Provenance Presented by E. H. Blakesley, Esq.
1929-6-11-72
Reference D 345; A 11, third state, as used for the poster.

After an earlier state without the address had been published by Kleinmann in a signed and numbered edition at 10 francs, this poster was used as an advertisement for the Jardin de Paris. Lautrec had known the dancer Jane Avril (called 'La Mélinite') since 1890; this poster was occasioned by her return to the stage after a retirement for two years in July 1893. Lautrec's friendship with Jane Avril lasted throughout his life, and one of the last posters he made was of her. With Yvette Guilbert, she was the only performer in whom Lautrec never lost interest.

The design of this poster is perhaps the most brilliant that Lautrec ever made. The pose chosen was one of Avril's favourites; Adriani (p. 60) reproduces a photograph of her in this position. The colour focuses attention on Avril while the design is held together by the borderline which grows out of the neck of the double bass. A letter bears witness to the keen competition between the Parisian newspaper proprietors to obtain the rights to reproduce this poster (Letters, p. 159).

92 Jane Avril

1893
In black. 265 × 212 mm
Provenance Purchased from Ducrot, Paris, in 1930; Dodgson bequest. 1949-4-11-3613
Reference D 28; A 17, first state.

In the first state this lithograph was the first plate in the album *Le Café-Concert*. This contained eleven lithographs each by Lautrec and H. G. Ibels with a text by Georges Montorgueil, and was published by *L'Estampe Originale* in an edition of fifty. The lithographs all show figures from the Parisian music hall.

93 Jane Avril

1893
In olive-green. 252 × 220 mm
Provenance Presented by H. J. L. Wright, Esq. 1924-10-10-1
Reference D 28; A 17, second state, with lettering.

The lithograph was later re-used as a cover for a sheet of music published by Bosc; written for the piano by Ad. Gauwin the piece is entitled: *All Right – Polka-Mazurka – Dansée par Jane Avril au Jardin de Paris*. To fit in the lettering the composition had to be extended at the bottom and sides. The copyright declaration – '*tout exemplaire tiré sans la musique est la propriété de l'auteur*' – is a reminder of the commercial considerations which lay behind all these publications.

94 Edmée Lescot

1893
In black. 269 × 189 mm
Provenance Purchased from Ducrot in 1930; Dodgson bequest. 1949-4-11-3615
Reference D 32; A 21

This is the fifth plate that Lautrec supplied for the *Café Concert* series.

95 Les vieilles histoires: couverture-frontispiece

1893
Five colours. 338 × 546 mm. With Lautrec's red stamp (L 1338).
Provenance Presented by Dodgson. 1920-5-22-42
Reference D 18; A 28, second state, published in an edition of about forty.

This print, folded down the centre, and with some extra lettering, served as the outer cover for a collection of songs by Jean Goudezki set to music by Désiré Dihau. Each piece was published separately and had its own cover design (five by Lautrec, the remainder by Ibels and others), and so this wrapper seems to have been commissioned by the publisher Ondet as an inducement to buy the whole set. Lautrec's striking design must have served this purpose admirably. Dihau, who is the man in the top hat, was Lautrec's cousin; he appears in Degas' painting *L'Orchestre de l'Opéra* (in the Louvre) playing the bassoon. The bear is Goudezki.

95

96 Carnot malade!

1893
Colouring applied by stencil. 270 × 175 mm
Provenance Purchased from Ducrot in 1930; presented by
Dodgson. 1930-2-22-1
Reference D 25; A 35, third state, with lettering.

This is another of the music covers commissioned by
Ondet; it does not however belong to the series of the
Vieilles Histoires. The fourth page of the sheet carries a
listing of numerous songs which Ondet had in stock.
The song comes from the music hall, *Le Chat Noir,* and
was prompted by the illness in the summer of 1893 of
the French president, Sadi Carnot. Carnot in fact
recovered from his illness, but was stabbed to death by
an anarchist in June of the following year.

 This impression is interesting in that it has
overprinted in red an advertisement for the special
collectors' proofs of this actual print which were being
offered for sale by Kleinmann (who obviously had
commercial relationships with Ondet). The advertise-
ment specifies the size of the special edition: twenty

proofs, numbered 1–20, on Japan; forty, numbered
21-60, on China; and forty, numbered 61–100 on
wove and coloured by stencil. (Cf. 97.)

97 Pauvre Pierreuse!

1893
Printed in green on China paper. 237 × 170 mm. Signed
and numbered 32, and with Kleinmann's blindstamp
(L 1573).
Provenance Dodgson bequest. 1949-4-11-3612
Reference D 26; A 36, first state, one of twenty impressions
on China paper.

Like the preceding item, this is one of Ondet's music
covers of which 100 proofs before letter were published
by Kleinmann. The lettering in the second state fills all
the white areas; the song comes from the repertoire of
Eugénie Buffet and calls itself a '*chanson réaliste*'.
Pierreuse is slang for a prostitute.

98 Le Coiffeur

1893
Four colours. 326 × 240 mm. Signed and numbered 15;
with Kleinmann's blindstamp (L1573).
Provenance Purchased from the Leicester Galleries in 1930
for 18 guineas; Dodgson bequest. 1949-4-11-3610
Reference D14; A38, second state, before letters, published
in an edition of 100.

This impression belongs to an edition specially printed
for collectors. In the third and final state lettering was
added to the upper left half and the print used for a
programme for the Théâtre Libre. The plays, which
opened in November, were *Une Faillite* and *Le Poète et le
Financier.*

99 Mlle Lender et Baron

1893
In black. 316 × 231 mm. Not signed, stamped or
numbered.
Provenance Dodgson bequest. 1949-4-11-3616
Reference D43; A45, from the edition of 100.

Between November 1893 and March 1894 Lautrec
supplied twelve illustrations for the short-lived weekly
journal *L'Escarmouche.* The journal was edited by
Georges Darien and H. G. Ibels, who was one of the
best-known lithographers of the period. The paper
itself only contained reproductions; the original
lithographs were published and sold separately in
editions of 100.

The lithographs all show scenes from the stage. In
this print Marcelle Lender (cf. 106) is with 'Baron', the
actor Louis Bouchenez who received his nickname
from having played Baron Gros in *La Grande Duchesse.*
The Department possesses a related drawing of Lender
from the de Hauke bequest.

100 Répétition Générale aux Folies-Bergère

1893
In black. 371 × 260 mm. Numbered 40 and with
Lautrec's stamp (L1338).
Provenance Presented by Dodgson. 1922-12-18-6
Reference D44; A47, from the edition of 100.

This also belongs to the series of illustrations made for
L'Escarmouche. Both this and the previous item were
reproduced in the issue of 3 December 1893. The scene
shows Emilienne d'Alençon being taught how to dance
by Mariquita of the Opera.

101 Réjane et Galipaux, dans *Madame Sans-Gêne*

1894
In green, on wove paper. 314 × 255 mm. Numbered 22
and with Lautrec's stamp (L1338).
Provenance Dodgson bequest. 1949-4-11-3618
Reference D52; A64, from a total edition of ninety.

This lithograph was made for *L'Escarmouche,* but the
magazine collapsed and Kleinmann took over the
publication. The play *Madame Sans-Gêne* (Mrs Free-
and-Easy) was written by Sardou and Moreau; Réjane
took the part of la Maréchale Lefèbvre, a former
laundress whose husband was elevated by Napoleon.
In this scene the unwilling lady is being taught to
dance by the courtier Despréaux (acted by Galipaux).

102 Miss Ida Heath, danseuse anglaise

1894
In black on wove paper. 360 × 261 mm. Signed and with
the artist's stamp (L1338).
Provenance Dodgson bequest. 1949-4-11-3629
Reference D165; A66, from a total edition of sixty.

This is the only print that Lautrec made of this English
dancer. It is remarkable how many British performers
found their way to the Parisian stage at this period.

103 La Loge au mascaron doré

1894
Four colours. 372 × 300 mm. Signed and numbered 24;
with Kleinmann's blindstamp (L1573).
Provenance Dodgson bequest. 1949-4-11-3611
Reference D16; A71, second state, before letters, published
in an edition of 100.

This print was made, and used with lettering added in
the centre left, as the programme for a play at the
Théâtre Libre, *Le Missionnaire,* which opened in April
1894. This impression belongs to a special early
edition run off for collectors (cf. 98). The print takes its
name from the remarkable gilded mask on the front of
the box. Delteil identifies the man sitting in the box at
the left as the Anglo-Australian artist Charles Conder
(1868–1909), who lived in Paris from 1890–4 and
was often drawn by Lautrec. The composition is
inspired by Degas (e.g. the oil illustrated by Adriani
p. 90).

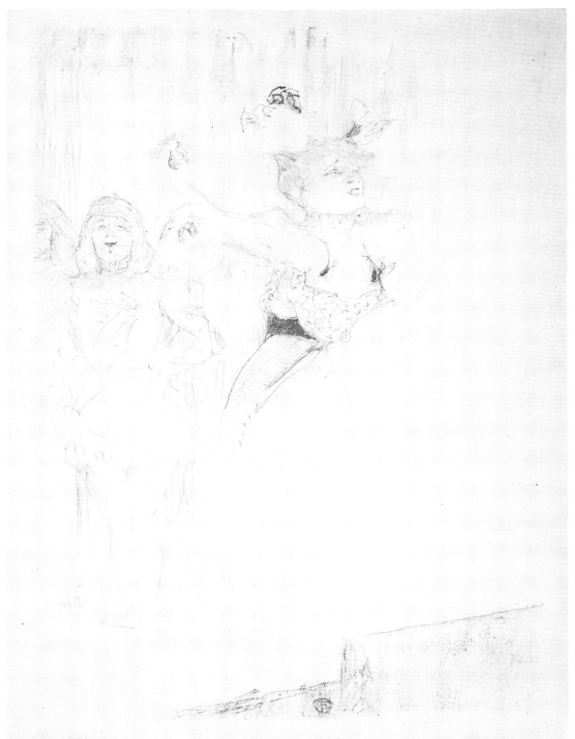

104 Carnaval

1894
In green with red. 245 × 160 mm (trimmed)
Provenance Purchased from Ducrot in 1930; Dodgson
bequest. 1949-4-11-3620
Reference D 64; A 76, third state, from the edition of 100.

This lithograph was first published in *La Revue Blanche*
of March 1894; in 1895 it was reprinted in the
anthology *Album de la Revue Blanche* in an edition of
100. Thadée Natanson, the editor of the *Revue*, in his
memoirs of Lautrec recalls the artist's delight at using a
second stone merely for the touch of red of the lady's
lips.

105 Couverture de l'Estampe Originale

1895
Three colours. 585 × 827 mm. Signed in pencil.
Provenance Presented by Dodgson. 1920-5-22-43 and 44
(mounted as two sheets)
Reference D 127; A 107, third state.

This lithograph folded into two halves to serve as the
wrapper for the last livraison of *L'Estampe Originale*,
which was published in March 1895. The elephant
and the list of contents join the man raising the curtain
on the front cover; on the back, watching the curtain
rise from the audience's side is Misia Natanson.

The elephant reappears in Lautrec's programme
cover (A 105) for a play translated from the Hindustani
called *Le Chariot de Terre Cuite*, which opened in
January 1895 at the Théâtre de l'Oeuvre. Lautrec had
in fact designed the stage set for this production. An
eyewitness reports that in the foreground on the right
was a mountain of cactus while on the left was an
elephant in profile; the backcloth was a painted vision
of India (Joyant 1927, p. 42). Probably this also
explains why Lautrec began to use occasionally a
monogram with an outline elephant in 1894.

106 Lender dansant le pas du boléro, dans 'Chilpéric'

1895
In green. 367 × 263 mm
Provenance Presented by Percy Moore Turner, Esq.
1938-10-8-107
Reference D 104; A 115, from an edition of fifty.

Chilpéric was an operetta by Hervé which was set in the
period of the Merovingians; hence the outlandish
costumes. It was revived at the Variétés in February
1895 with enormous success. Lautrec, who had
already drawn Marcelle Lender in 1893 (see 99), made
no less than eleven lithographs inspired by the play or
by Lender.

Maurice Joyant (1927, p. 46) recalls: '*Que de fois, aux
Variétés, à gauche, a-t-il attendu au même fauteuil
d'orchestre, le moment où Lender, dans Chilpéric, danse son
pas de boléro.*' Such periods of intensive observation
seem always to have preceded a series of prints devoted
to one actress.

107 Lender saluant

1895
In green. 317 × 256 mm. Numbered *12*, and with
Lautrec's (L 1338) and Kleinmann's (L 1573) stamps.
Provenance Dodgson bequest. 1949-4-11-3621
Reference D 107; A 117, from an edition of fifty.

To judge from the costumes of the figures in the
background this is also a scene from *Chilpéric*.

108 Mlle Marcel Lender, en buste

1895
(See colour plate facing page 72.)
Eight colours. 325 × 246 mm. Numbered *37/100*, with
Lautrec's stamp (L 1338).
Provenance Presented by the Contemporary Art
Society. 1922-7-8-29
Reference D 102; A 118, fourth state.

This impression matches Delteil's second state; it
corresponds to Adriani's IVa except that it lacks the
inscription IIe and the *Pan* blindstamp. The lithograph
was published in a very large edition in the German
magazine *Pan* in 1895 (Jahrgang I, Heft 3, facing p.
196); it was commissioned by the famous critic Julius
Meier-Graefe. The other editors were deeply offended at
this irruption of decadent French taste into an all-
German magazine, and Meier-Graefe lost his job.

109 Lender assise

1895
In black. 352 × 242 mm. No number or stamp.
Provenance Dodgson bequest. 1949-4-11-3628
Reference D 163; A 120, from an edition of twenty.

This print was published by Kleinmann. The lack of number and stamp may mean that this is a trial proof, or simply that Kleinmann forgot to put them on.

110 Lender et Auguez, dans *La Chanson de Fortunio*

1895
In green. 370 × 215 mm. Not signed, numbered or stamped.
Provenance Dodgson bequest. 1949-4-11-3622
Reference D 108; A 123, from an edition of twenty.

This lithograph shows Marcelle Lender in another rôle she played in this year, in an operetta by Offenbach.

111 Luce Myrès, de profil

1895
In green. 221 × 209 mm. Numbered *17*, and with the stamps of Lautrec (L 1338) and Kleinmann (L 1573).
Provenance Dodgson bequest. 1949-4-11-3625
Reference D 124; A 124, from the edition of twenty.

Luce Myrès appears in only two lithographs; she had a part in Offenbach's *La Périchole* at the Variétés.

112 Luce Myrès, de face

1895
In green. 353 × 240 mm. Not signed or numbered.
Provenance Dodgson bequest. 1949-4-11-3626
Reference D 125; A 125, from an edition of twenty.

This print, with its companion, was published by Kleinmann. Compare the note on 109.

113 Miss May Belfort saluant

1895
In black on wove paper. 360 × 255 mm
Provenance Dodgson bequest. 1949-4-11-3623
Reference D 117; A 131, from an edition of sixty-five.

May Belfort (properly May Egan) was born in Ireland; after working in the music halls of London, she arrived in Paris in January of 1895, where she performed at the Cabaret des Décadents. Her act included dressing in baby clothes and carrying a small black cat. It caused a sensation for a few months, but she soon dropped out of sight. Lautrec made a series of six lithographs of her. He also concerned himself in her domestic matters, as the following letter to Maxime Dethomas shows: '*Miss Belfort demande un époux pour sa chatte. Est ce que votre chat de Siam est mûr pour la chose? Un petit mot s.v.p. et fixez-nous un rendez-vous.*' (Letters p. 285.)

114 Miss May Belfort (grande planche)

1895
Two colours. 546 × 421 mm. Signed and numbered *16*.
With Lautrec's (L 1338) and Kleinmann's (L 1573) stamps.
Provenance Dodgson bequest. 1949-4-11-3624
Reference D 119; A 133, third state, from the edition of twenty-five.

115 May Belfort

1895
(See front cover)
Four colours. 795 × 610 mm. With a remarque of a cat with a ruff; signed and numbered *15/25*.
Provenance Presented by Dodgson. 1925-10-7-3
Reference D 354; A 136, third state, with remarque, published in an edition of twenty-five.

After various editions for collectors, this print was used as a poster to advertise the Petit Casino.

116 La Passagère du 54

1895 or 1896
(See colour plate between pages 72 and 73.)
Six colours. 610 × 443 mm. Numbered *35*, and with Lautrec's signature and stamp (L 1338).
Provenance Presented by Dodgson. 1914-3-24-6
Reference D 366; A 145, second state, from an edition of 100.

In the third state this lithograph served as a poster, with the lettering added: '*Salon des Cent, 31 Rue Bonaparte, Exposition Internationale d'Affiches*'. The Salon des Cent was the same gallery as the Salon de la Plume, where the *Elles* series was shown.

The model was an unknown woman who had drawn Lautrec's attention on a journey he made by steamship between Le Havre and Bordeaux. The story is that he was so attracted by her that he refused to disembark at Bordeaux but continued to Lisbon where his companion Maurice Guibert finally got him to land. The lady, whom Lautrec never formally met, occupied

LEFT TOP 146 Bonnard *Coin de Rue*
LEFT 152 Bonnard *Le Pont des Arts*

OVERLEAF 110 (left), 112

cabin number 54, whence the print's title. Dortu places this escapade in 1896, which conflicts with Adriani's dating of the poster to 1895.

117 La Valse des Lapins

1895
In black. 315 × 235 mm. Signed, with Lautrec's stamp (L 1338).
Provenance Presented by Dodgson. 1922-12-18-7
Reference D 143; A 162, one of the rare examples of the first state before added lettering.

With added lettering, this lithograph was used as the cover for a piece of music published by Bosc.

118 Oscar Wilde et Romain Coolus

1896
300 × 490 mm. The print has in the past been folded into eight.
Provenance Presented by Dodgson. 1922-12-30-36
Reference D 195; A 167, fourth state.

In this state, with the text printed typographically, the print was used as the programme for the Théâtre de l'Oeuvre in February 1896. The programme was a double bill of Coolus' play *Raphael* and Oscar Wilde's *Salome*. The portraits are of the two authors. Lautrec here redrew a portrait of Wilde which he had made in London in May 1895, a few days before Wilde's final, disastrous trial, (Joyant 1926, p. 175). Coolus was a great friend of Lautrec.

119–131 Elles

April 1896

The set of lithographs by Lautrec entitled *Elles* contained a cover, frontispiece and ten plates; it was published by Gustave Pellet in an edition of 100 on specially made paper with the watermark *G. Pellet – T. Lautrec*. The price was 300 francs, or 35 for the individual prints. All the sets are supposed to have had each plate numbered and initialled by Pellet; this set, however, although the cover is initialled and numbered 72, has no marks on the individual plates. It was bought by Dodgson in November 1925 from J. H. de Bois in Haarlem, and came to the Department with his bequest. The titles of the plates have been supplied by later cataloguers.

Elles has always been regarded as Lautrec's greatest achievement in colour lithography, and shows a total mastery of the medium. His use of a coloured toneplate (e.g. in 128) is apparently quite new, as is the way in which the images are bled off at the edges.

The series is the outcome of the many weeks between 1892 and 1895 which Lautrec spent living in various Parisian brothels (cf. Joyant 1926, pp. 149 ff.); on one occasion he gave his address at one of these to the famous dealer Durand-Ruel who was, as Lautrec intended, most shocked when he arrived for the appointment in his carriage. The choice of subjects is remarkable; only two of the images give a clue that the setting is in a brothel, and it would seem that Lautrec was above all attempting to convey a routine of everyday life. A reviewer in *La Plume* (1896, p. 305) described them as '*ébauches et croquis d'une cruauté d'exactitude merveilleuse*'. But Lautrec is not quite heartless. His detachment comes not from contempt, but from sympathy and the ability to accept people without presuming to judge or criticise them. Such honesty must have come more easily to one who was himself a cripple and outcast. (Cf. the comparison between Lautrec and Degas by Douglas Cooper: *Toulouse-Lautrec*, London, 1955, p. 12.)

119 Frontispice pour *Elles*

535 × 405 mm (trimmed). Inscribed: *Série no. 72* with Pellet's monogram (L 1194) and with his stamp in blue (L 1190). Not signed.
Provenance Dodgson bequest. 1949-4-11-3634
Reference D 179; A 177, first state.

In the first state this was used as the cover of the series.

120 Frontispice pour *Elles*

(See colour plate between pages 72 and 73.)
Three colours. 516 × 405 mm (slightly trimmed at the top)
Provenance Presented by Dodgson. 1925-10-14-1
Reference D 179; A 177, second state.

The woman's dress has been strengthened with lithographic wash. In this state the print was used as the frontispiece for the set.

114▷

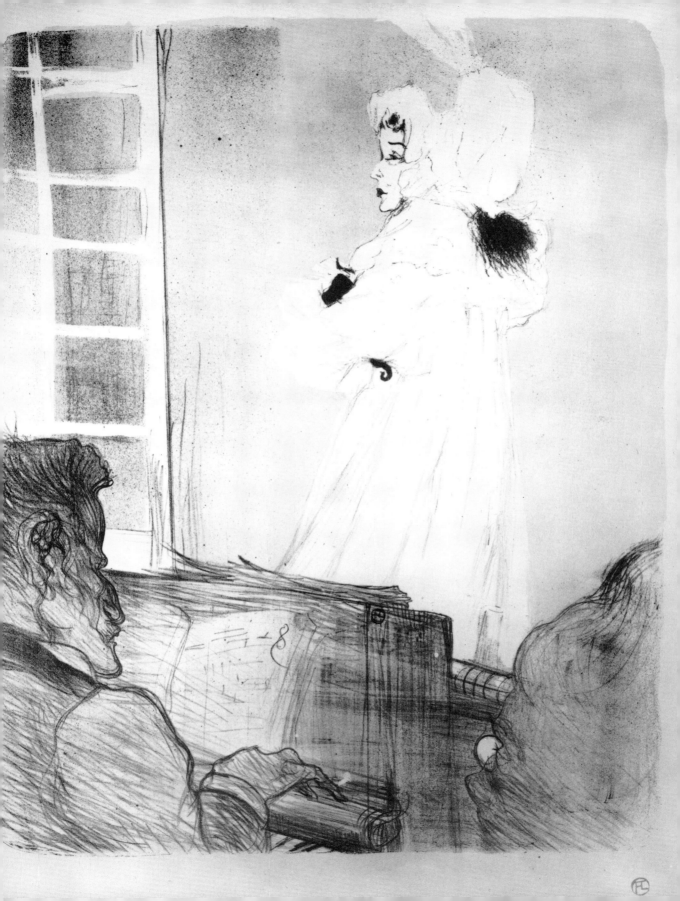

121 Frontispice pour *Elles*

Three colours. 628 × 475 mm (sheet size). Numbered very faintly 39, and with Pellet's stamp (L1190).
Provenance Dodgson bequest. 1949-4-11-3633
Reference D179; A177, trial proof of the third state.

On this sheet the composition is printed in full; in the previous exhibit it was bled off at the sides. The composition thus extended was used by Pellet as a poster to advertise the exhibition of the *Elles* series at La Plume from 22 April 1896. This is presumably a trial proof for the poster since the lettering is not yet added; however the number 39 suggests that an (unrecorded) edition was run off at this stage. The colours differ markedly in shade from those of the frontispiece.

122 La Clownesse, Mlle Cha-U-Kao

Four colours. 525 × 404 mm
Provenance Dodgson bequest. 1949-4-11-3635
Reference D180; A178, second state.

Mlle Cha-U-Kao reappears in several other lithographs by Lautrec. She was employed at the Moulin Rouge. Her name is simply an orientalized version of 'Chahut-Chaos' – a name given to a dance. This plate is exceptional in the series not only in its strong colours, but in that Mlle Cha-U-Kao was not a prostitute but a dancer.

123 Femme au plateau

In sanguine. 400 × 522 mm
Provenance Dodgson bequest. 1949-4-11-3637
Reference D181; A179

124 Femme couchée

In green. 403 × 524 mm
Provenance Dodgson bequest. 1949-4-11-3636
Reference D182; A180

125 Femme au Tub

Five colours. 412 × 534 mm
Provenance Dodgson bequest. 1949-4-11-3638
Reference D183; A181, second state.

126 Femme qui se lave

Two colours. 523 × 403 mm
Provenance Dodgson bequest. 1949-4-11-3639
Reference D184; A182, second state.

127 Femme à glace

Three colours. 522 × 404 mm
Provenance Dodgson bequest. 1949-4-11-3640
Reference D185; A183, second state.

128 Femme qui se peigne

One colour over a green toneplate. 523 × 401 mm
Provenance Dodgson bequest. 1949-4-11-3641
Reference D186; A184, second state.

129 Femme au lit, profil

(See colour plate facing page 73.)
Four colours. 401 × 522 mm
Provenance. Presented by the Contemporary Art Society. 1922-7-8-30
Reference D187; A185, fourth state.

130 Femme en corset

Five colours. 524 × 405 mm. With Lautrec's blue stamp (L1338).
Provenance Dodgson bequest. 1949-4-11-3642
Reference D188; A186, second state.

131 Femme sur le dos

One colour over a green toneplate. 402 × 520 mm
Provenance Dodgson bequest. 1949-4-11-3643
Reference D189; A187, second state.

132 Le Sommeil

1896
In sanguine on Japan. 226 × 317 mm. Signed and numbered 9, with Lautrec's stamp (L1338).
Provenance M. Guérin (L1872b), (sale Sotheby's 23 March 1926, lot 51, bt. Colnaghi, £36); Dodgson bequest. 1949-4-11-3630
Reference D170; A188, from an edition of twelve.

This was only published in an edition of twelve, and is therefore very rare.

133 Au Concert

1896
Four colours. 318 × 253 mm. Signed by the artist.
Provenance Claude Roger-Marx (L2229); presented by Dodgson. 1922-12-18-8
Reference D365; A202, second state, with the copyright line.

This lithograph was commissioned from Lautrec by

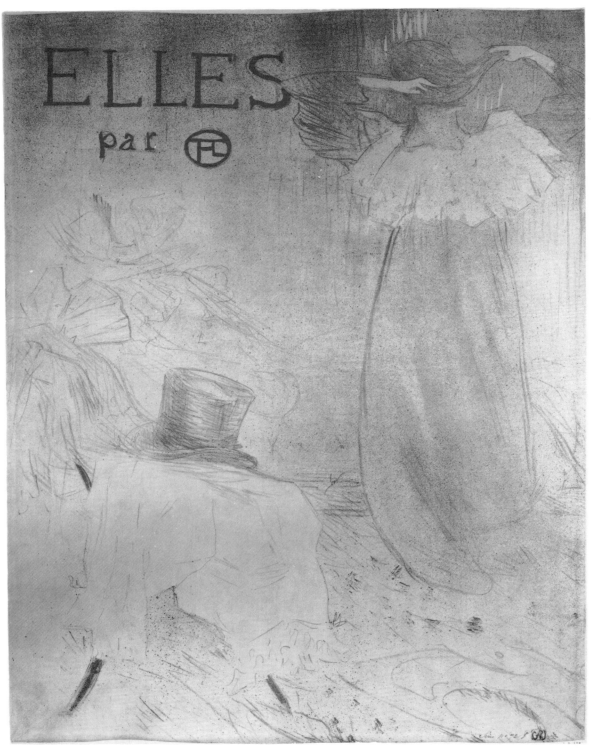

119

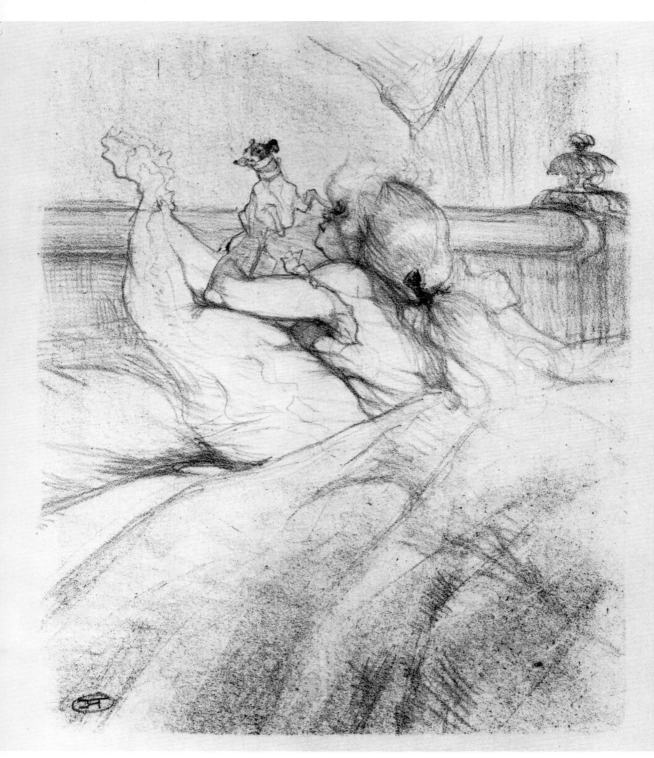

RIGHT 171 Vuillard *La Pâtisserie*

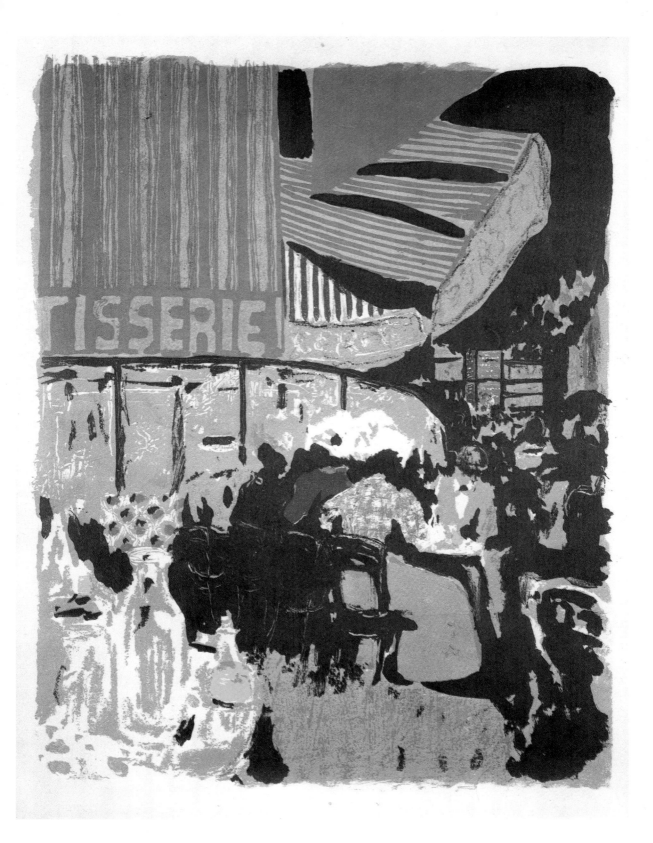

Ault and Wiborg, the American manufacturers of lithographic ink. This impression belongs to a small edition run off in Paris; the zinc plates were then shipped to America and the lettering added before the main edition was printed. The four original zinc plates are now in the Art Institute of Chicago. This is said to be the only lithograph that Lautrec made on zinc; zinc obviously ran fewer risks than stone on the trans-Atlantic crossing.

The models are Gabriel Tapié de Céleyran, Lautrec's cousin, and Emilienne d'Alençon.

134 La petite loge

1897
Four colours. 238 × 317 mm. Signed and numbered 6.
Provenance Dodgson bequest. 1949-4-11-3644
Reference D 209; A 212, second state, from an edition of twelve.

This lithograph was published by Pellet in an edition of only twelve impressions. All the impressions have their margins trimmed.

135 Partie de Campagne

1897
(See colour plate facing page 73.)
Six colours. 400 × 516 mm. Numbered 86, and with Lautrec's stamp (L 1338).
Provenance Presented by Dodgson. 1914-3-24-5
Reference D 219; A 216, third state, from the edition of 100.

After a few early trial states, this lithograph was published in an edition of 100 by Vollard in his second *Album des Peintres-Graveurs*. This is the only print by Lautrec which was published by Vollard.

136 Au Lit – Femme au chien

1898
310 × 253 mm
Provenance Presented by Percy Moore Turner, Esq. 1938-10-8-108
Reference D 226; A 302, from an edition of fifty.

137 Chanteuse légère

1898
315 × 260 mm
Provenance Presented by Percy Moore Turner, Esq. 1938-10-8-109
Reference D 269; A 313, from an edition of forty.

It appears that no one knows who the singer is.

138 Au Star, Le Havre

1899
On Japan paper. 455 × 364 mm
Provenance Bought by Dodgson at Sotheby's (sale 23 March 1926, lot 188) for £8; Dodgson bequest. 1949-4-11-3648
Reference D 275; A 351, from an edition of fifty.

In May 1899 Lautrec was released from the clinic after his cure from alcoholism, and was dispatched to the south of France to complete his cure. This lithograph records an English barmaid at the Star in Le Havre where he was waiting to take a boat to Bordeaux. Joyant thought that this print was done on a journey before 1899, but a painting of the same model (Dortu 684) which is dated 1899 proves him wrong.

139 Le Jockey

1899
In black, on China paper. 540 × 415 mm
Provenance Dodgson bequest. 1949-4-11-3649
Reference D 279; A 356, first state, one of an edition of 100.

This lithograph, one of the last made by Lautrec, was drawn for an intended set of racetrack subjects, to be published by Pierrefort. Although some others were made, Lautrec's health did not allow him to complete the series. The lithograph was finally published in two editions: one with just the black drawing, the other with the colour stones added.

140 Le Jockey

1899
Six colours, on Japan paper. 530 × 370 mm
Provenance Dodgson bequest. 1949-4-11-3650
Reference D 279; A 356, second state, one of twelve impressions on Japan.

Of the edition in colour, 100 were printed on wove paper and twelve on Japan.

141 Mme Simon-Girard, Brasseur et Guy, dans *La Belle Hélène*

?1900
In black. 525 × 455 mm
Provenance Dodgson bequest. 1949-4-11-3652
Reference D 114; A 364, from an edition of thirty.

Delteil dated this work to 1895. Joyant (1926, p. 233) prints a letter from Lautrec in Bordeaux of 6 December 1900 which proves that Lautrec was watching

Offenbach's operetta there: '*Ici la 'Belle Hélène' nous charme . . . j'ai déjà attrapé la chose. Hélène est jouée par une gross p— qui s'appelle Cocyte.*' There is real doubt to which date this print belongs. The uncertain draughtsmanship distinguishes this lithograph from the documented ones of 1895, and suggests that the later date might be correct. If so, this is almost Lautrec's last lithograph.

Pierre Bonnard

1867–1947

Studied law in Paris from about 1885 to 1888; later attended the Ecole des Beaux-Arts and the Académie Julien where he met the group of painters, including Vuillard (qv.), who took the name of Nabis in 1891. Decisively influenced by the exhibition of Gauguin's Breton paintings at the Café Volpini in 1889.

Bonnard's first lithograph was a poster, *France-Champagne*, commissioned in 1889 by a wine merchant and published in 1891. This work came to the attention of Toulouse-Lautrec, whom Bonnard may have introduced to lithography. Together with Vuillard, Bonnard published lithographs in *La Revue Blanche* and André Marty's *L'Estampe Originale*. The flat, unmodulated colour of Japanese prints, in particular of Hiroshige's street scenes, conveyed to him '*qu'il était possible de traduire lumière, formes et caractère rien qu'avec la couleur, sans faire appel aux valeurs*' (quoted in A. Terrasse: *Pierre Bonnard*, Paris, 1967, p. 24). This was equally applicable to the development of his style as a painter:

I learned much about painting proper from making lithographs in colour; when one has to establish relations between tones by ringing the changes on only four or five colours, superimposed or juxtaposed, one makes a host of discoveries.

(Quoted by D. Sutton: Royal Academy Exhibition Catalogue, 1966, pp. 13–14.) Bonnard's first one-man exhibition at Durand-Ruel's in 1896 included a number of lithographs; in 1896 and 1897 he contributed to Vollard's two albums while working on the series *Quelques Aspects de la vie de Paris*. André Mellerio, in *La Lithographie Originale en Couleurs*, 1898, for which Bonnard executed the frontispiece, applauded the artist's ability to use colour lithography

as an expressive medium in its own right: '*Il y apparaît de conception affinée en même temps que de métier simple, visant à une harmonie délicate, à un dessin concis très expressif tout en montrant une grâce d'arabesque* (op. cit. p. 9). After 1900, like Vuillard, he abandoned the individual colour lithograph, but continued to illustrate books in the medium of which his masterpiece was Vollard's edition of Verlaine's *Parallèlement* in 1900.

Bibliography
R-M = C. Roger-Marx: *Bonnard Lithographe*, Monte Carlo, 1952.
R.A. = *Pierre Bonnard*, Exhibition Catalogue, Royal Academy, 1966.
Johnson = U. E. Johnson: *Ambrose Vollard Editeur*, New York, 1977.

142 Le Canotage

1897
Four colours on China paper. 270 × 480 mm
Provenance Dodgson bequest. 1949-4-11-3173
Reference R-M 44

This lithograph was published in an edition of 100 by Vollard in his second collection entitled *Album d'estampes originales* of 1897. The composition corresponds almost exactly to that of a painting of 1896–7, *Canotage sur la Seine* (R.A. no. 28 repr.).

143 Fiacres en station

1899
Five colours. 275 × 480 mm
Provenance Presented by the Contemporary Art Society. 1945-12-8-198
Reference R-M 47

This frieze formed the topmost section of the third leaf of a four part screen which was published by Molines in an edition of 110 in 1899. The individual sheets were originally advertised for sale at 40 francs unmounted and 60 francs mounted. The screen as a whole constitutes the most complete expression of Japanese influence upon Bonnard's work.

144-156 Quelques Aspects de la vie de Paris
1895

This album of twelve lithographs plus a cover was commissioned from Bonnard by Vollard; it is exhibited here complete. All the lithographs were printed in colour on wove paper except for the cover which was on China paper; some trial proofs were printed in black on a paper with large margins. The album was commissioned and apparently printed in 1895, but was only published in 1899 in an edition of 100. A few years after publication some sets were returned to the artist who added his signature to each individual print; our set, being signed, is presumably one of these.

Quelques Aspects de la vie de Paris was exhibited by Vollard in 1899 together with the companion volume by Vuillard, *Paysages et Intérieurs*. (For Mellerio's comments on these prints see the entry for the album by Vuillard, 161). The street scenes reflect Bonnard's interest in the woodcuts by Hiroshige, of which he himself had a collection.

144 Cover for *Quelques Aspects de la vie de Paris*
Two colours. 410 × 340 mm. Signed.
Provenance Dodgson bequest. 1949-4-11-3161
Reference R-M 56

Roger-Marx suggests that the scene is set in the Place Dancourt.

145 Avenue de Bois
Five colours. 310 × 470 mm. Signed.
Provenance Dodgson bequest. 1949-4-11-3170
Reference R-M 57

It was presumably to this print that Vollard refers in his *Recollections* (English trans. by V. M. Macdonald, London, 1936, p. 248): 'From Bonnard, for instance, I had a series of coloured lithographs of Paris – "Here's my wife and daughter in this *Retour du Bois!*" cried Helleu, looking at them, so recognizable were the figures in the crowd.'

146 Coin de rue
(See colour plate facing page 81.)
Four colours. 270 × 360 mm. Signed.
Provenance Dodgson bequest. 1949-4-11-3172
Reference R-M 58

147 Maison dans la cour
(See colour plate facing page 80.)
Four colours. 350 × 260 mm. Signed and numbered 99.
Provenance Dodgson bequest. 1949-4-11-3174
Reference R-M 59

A related painting, datable 1895–1900, is in the Smith College Museum of Art, Northampton. Mass. (R.A. 25). An undescribed trial proof retouched by hand is mentioned by Johnson.

148 Rue vue d'en haut
Four colours. 370 × 230 mm. Signed.
Provenance Dodgson bequest. 1949-4-11-3167
Reference R-M 60

149 Boulevard
Four colours. 175 × 435 mm. Signed and numbered 37.
Provenance Dodgson bequest. 1949-4-11-3163
Reference R-M 61

Johnson describes a trial proof touched by hand. A related painting, *Les Grands Boulevards*, of ca. 1895–1900, is in the collection of Mr and Mrs R. J. Sainsbury (R.A. 26, repr.).

150 Place Le Soir
Four colours. 280 × 380 mm. Signed.
Provenance Dodgson bequest. 1949-4-11-3168
Reference R-M 62

A preparatory sketch is described by Johnson.

151 Marchand des Quatre-Saisons
Five colours. 290 × 340 mm. Signed.
Provenance Dodgson bequest. 1949-4-11-3175
Reference R-M 63

152 Le Pont des Arts
(See colour plate facing page 81.)
Four colours. 270 × 410 mm. Signed.
Provenance Dodgson bequest. 1949-4-11-3166
Reference R-M 64

153 Au Théâtre

Four colours. 210 × 400 mm. Signed.
Provenance Dodgson bequest. 1949-4-11-3169
Reference R-M65

The spectator in the foreground with the bald head and squashed nose appears to be Vollard.

154 Rue Le Soir sous la pluie

Five colours. 260 × 355 mm. Signed and numbered 58.
Provenance Dodgson bequest. 1949-4-11-3162
Reference R-M66

155 L'Arc de Triomphe

Five colours. 310 × 470 mm. Signed.
Provenance Dodgson bequest. 1949-4-11-3165
Reference R-M67

156 Coin de rue vue d'en haut

Four colours. 365 × 210 mm. Signed and numbered 79.
Provenance Dodgson bequest. 1949-4-11-3164
Reference R-M68

157 Les Boulevards

1900
Four colours. 260 × 330 mm
Provenance Dodgson bequest. 1949-4-11-3157
Reference R-M74

This lithograph was published in an edition of 100 in an album published in Leipzig in 1900 by Insel Verlag; Julius Meier-Graefe seems to have been behind the publication. Vuillard (cf. 175), Cross and others also contributed.

Edouard Vuillard

1868–1940

In 1877 Vuillard's family moved to Paris where he attended the Lycée Condorcet, in the company of many of his future artistic associates: the painters, Bonnard, Maurice Denis and Ker-Xavier Roussel, (subsequently his brother-in-law); Thadée and Alexandre Natanson, publishers of *La Revue Blanche*, and Aurélien Lugné-Poe, producer and director of the Théâtre de l'Oeuvre. In 1886 he entered the Ecole des Beaux-Arts, and in 1888 he joined the Académie Julien with Roussel; his fellow students included the nucleus of the Nabis, Bonnard, Denis, Felix Vallotton and Paul Sérusier. In 1890 he was sharing a studio at 28, rue Pigalle, with Bonnard, Denis and Lugné-Poe. By 1893 his paintings had already attracted the critics' attention and he achieved rapid success during this decade. In contrast with this early publicity, he withdrew almost completely from exhibition after 1914, until the retrospective exhibition organized at the Musée des Arts Decoratifs in 1938.

The poet, Stéphane Mallarmé, was an influential spiritual mentor, but the style and 'intimiste' subject matter of his work were primarily influenced by the Japanese woodcut, seventeenth-century Dutch art and the domestic milieu he inhabited with his mother, a professional seamstress, until her death in 1928.

Vuillard began his study of lithography in 1892–3 at the studio of the printer, Edouard Ancourt, where Bonnard and Toulouse-Lautrec worked; an unpublished black and white lithograph by K.-X. Roussel records him seated before one of his stones (Berès, no. 121). His early exercises in this medium were published in *La Revue Blanche* or issued as programmes for Lugné-Poe's Théâtre de l'Oeuvre, for which he also designed scenery. He received his first commission from Vollard in 1896 which prompted a far more complex exploration of colour lithography than he had hitherto essayed, employing four, five and even six different stones. The considerable demands imposed by the use of such a range of colours are indicated by the number of preparatory sketches and trial proofs Vuillard executed for the prints published by Vollard. During the 1890s he produced approximately fifty lithographs, half of which were in colour, but after 1900 this fertility of invention was brought to an abrupt end, partly as a result of the unfavourable market.

Bibliography:
R-M = C. Roger-Marx: *L'Oeuvre gravé de Vuillard*, Monte Carlo, 1948.
Russell = J. Russell: *Edouard Vuillard 1868–1940*, Art Gallery of Ontario, Toronto, 1971.
Berès = H. Berès: *Vuillard: Le lithographe*, Exhibition Catalogue, Paris, 1956.

158 La Couturière

1894
Two colours. 260 × 160 mm
Provenance Presented by the Contemporary Art
Society. 1945-12-8-303
Reference R-M 13, third state.

This state was published in *La Revue Blanche*, vol. VI,
no. 27, January 1894, while a fourth state, with
margins, appeared in an edition of 100 in *L'Album de la
Revue Blanche* for 1895. Two other compositions of
approximately the same date show a similar treatment
of this subject: *La Couture*, 1892–5, (Russell, no. 14)
and *Femme Cousant*, 1895, (Russell, no. 33).

159 Le Jardin des Tuileries

1896
Four colours on China paper. 280 × 430 mm. Signed
upper right corner in crayon.
Provenance F. E. Bliss (sale Sotheby's 14 March 1923, lot
97, bt. Dodgson with another for £1 8s.); Dodgson
bequest. 1949-4-11-3594
Reference R-M 28, second state, from the edition of 100.

In its second state, this print was published by Vollard
in 1896 in his first *Album des Peintres-Graveurs*. It was
Vuillard's first commission from Vollard, and his first
lithograph to be printed from more than two stones.
Several preparatory studies were executed in pastel
and watercolour.

160 Jeux d'Enfants

1897
Four colours on China paper. 280 × 430 mm. Signed and
titled in pencil, lower right.
Provenance Purchased from the Redfern Gallery in 1939 for
£7; Dodgson Bequest. 1951-5-1-28
Reference R-M 29, third state.

Published by Vollard in an edition of 100 for his sequel
to the first *Album des Peintres-Graveurs*, entitled *Album
d'estampes originales de la Galerie Vollard*.

161–173 Paysages et Intérieurs

1899

This album was commissioned from Vuillard by
Vollard and published in 1899 in an edition of 100 at a
price of 175 francs. It contained twelve lithographs
plus a cover and is exhibited here in its entirety. All the
lithographs are printed in colour, and this particular
set is on China paper.

Paysages et Intérieurs is the culmination of Vuillard's
partnership with Vollard and his printer Auguste Clot.
It was published at the same time as Bonnard's
Quelques Aspects de la vie de Paris. In a review of the
Vollard publications of 1899 in *L'Estampe et l'Affiche*
(vol. III pp. 98–99) André Mellerio thus characterized
the differing uses of colour of the two artists in the two
albums:

*M Vuillard établit une assise de couleurs franches, tendant
de plus en plus à un équilibre à la fois solide et harmonieux.
Quant à M Bonnard, ami des petites taches papillotantes,
des lignes ultra-sinueuses, il présente une apparence plus
compliquée, où l'observation s'empreint d'un comique
spirituel . . .*

This series of prints expresses the synthesis that
Vuillard wrought between the European and Japanese
influences upon his style and choice of subject.

161 Cover to *Paysages et Intérieurs*

Three colours. 510 × 400 mm
Provenance H. M. Petiet; Dodgson Bequest. 1949-4-11-3595
Reference R-M 31

A preparatory study in pastel exists (Berès no. 31).

162 La Partie des Dames

Four colours. 340 × 307 mm
Provenance H. M. Petiet; Dodgson Bequest. 1949-4-11-3596
Reference R-M 32, third state.

A preparatory sketch is known (Berès no. 33). The
seated figure is Tristan Bernard, humorist and
dramatist, and the standing woman is Misia Godebski,
wife of Thadée Natanson, one of the founders of *La
Revue Blanche*. The subject was repeated by Vuillard in
a painting of 1906, entitled *La Partie des Dames à
Amfreville*.

163 L'Avenue

(See colour plate facing page 89.)
Six colours. 310 × 410 mm
Provenance Presented by the Contemporary Art Society.
1925-3-14-60
Reference R-M 33, second state.

There are several preparatory studies for this composition, including a number of trial proofs touched by hand (Berès nos. 35–40).

164 À travers Champs

Five colours. 260 × 350 mm
Provenance H. M. Petiet; Dodgson Bequest. 1951-5-1-27
Reference R-M 34, third state.

Several preparatory studies in pastel, and a trial proof are known (Berès nos. 42–44).

165 Intérieur à la suspension

Five colours. 350 × 280 mm
Provenance H. M. Petiet; Dodgson Bequest. 1949-4-11-3597
Reference R-M 35, third state.

Several preparatory studies exist.

166 Intérieur aux Tentures Roses I

Five colours. 340 × 270 mm
Provenance H. M. Petiet; Dodgson Bequest. 1949-4-11-3599
Reference R-M 36, fourth state.

167 Intérieur aux Tentures Roses II

Five colours. 340 × 270 mm
Provenance H. M. Petiet; Dodgson Bequest. 1949-4-11-3598
Reference R-M 37, second state.

168 Intérieur aux Tentures Roses III

Five colours. 340 × 270 mm
Provenance H. M. Petiet; Dodgson Bequest. 1949-4-11-3600
Reference R-M 38.

169 L'Âtre

Five colours. 340 × 275 mm
Provenance H. M. Petiet; Dodgson Bequest. 1949-4-11-3601
Reference R-M 39, second state.

Vuillard incorporated a colour chart into the margin of a hand-touched trial proof for this lithograph, (Berès no. 56).

170 Sur le Pont de l'Europe

(See colour plate facing page 89.)
Four colours. 310 × 350 mm
Provenance H. M. Petiet; Dodgson Bequest. 1949-4-11-3602
Reference R-M 40, second state.

A preparatory study in pastel (Berès no. 59) and a watercolour sketch which appears on the verso of a trial proof of *Les deux belles-soeurs* exist. Vuillard anticipated this composition in an oil painting of 1891, *Deux Fillettes* (Russell no. 5).

171 La Pâtisserie

(See colour plate facing page 88.)
Seven colours. 355 × 270 mm
Provenance H. M. Petiet; Dodgson Bequest. 1949-4-11-3603
Reference R-M 41

There exists a small painting of the same subject, according to Roger-Marx.

172 La Cuisinière

Five colours. 350 × 280 mm
Provenance H. M. Petiet; Dodgson Bequest. 1949-4-11-3604
Reference R-M 42, second state.

A preparatory drawing in charcoal is known (Berès no. 62).

173 Les deux Belles-Soeurs

Four colours. 355 × 280 mm
Provenance H. M. Petiet; Dodgson bequest. 1949-4-11-3605
Reference R-M 43, third state.

One preparatory sketch and a proof of an undescribed state are recorded (Berès nos. 65–66). The woman on the left in a dressing gown is Misia Natanson and the other, Marthe Mellot, the actress who married Louis-Alfred Natanson, the third of the brothers who edited *La Revue Blanche*.

174 Le Jardin devant l'Atelier

1901
Eight colours on China paper. 640 × 480 mm. Signed in pencil, bottom left.
Provenance Presented by Dodgson. 1938-11-30-4
Reference R-M 45, second state.

Published by Julius Meier-Graefe in an edition of 100 for *Germinal: Album de XX Estampes Originales*, the last of the French collectors' portfolios to include colour lithographs and the last print executed by Vuillard in this medium. *Vue plongeante sur un jardin*, c. 1900 (Russell no. 52), is a related composition in oil.

175 Une Galerie au Théâtre du Gymnase

1900
Five colours. 250 × 190 mm
Provenance Purchased from the Redfern Gallery in 1940 for 4 guineas; Dodgson bequest. 1949-4-11-3608
Reference R-M 48, third state.

Published in an edition of 100 in an album by Insel Verlag, Leipzig, 1900 (cf. 157). There exist at least two preparatory studies in bodycolour.

Complete list of lithographs in the Department of Prints and Drawings by the artists included in this catalogue

Pierre Bonnard

	Roger-Marx	
1949-4-11-3176	4	Scène de Famille. Signed and numbered 79.
1949-4-11-3173	44	Le Canotage.
1945-12-8-198	47	Fiacres en station. Upper portion of third panel of a set of four designed as a screen.
	56–68	*Quelques aspects de la vie de Paris.* Album of twelve lithographs and cover
1949-4-11-3161	56	Cover. Signed.
1949-4-11-3170	57	Avenue de Bois. Signed.
1949-4-11-3172	58	Coin de rue. Signed.
1949-4-11-3174	59	Maison dans la cour. Signed and numbered 99.
1949-4-11-3167	60	Rue vue d'en haut. Signed.
1949-4-11-3163	61	Boulevard. Signed and numbered 37.
1949-4-11-3168	62	Place Le Soir. Signed.
1949-4-11-3175	63	Marchand des Quatre-Saisons. Signed.
1949-4-11-3166	64	Le Pont des Arts. Signed.
1949-4-11-3169	65	Au théâtre. Signed.
1949-4-11-3162	66	Rue Le Soir sous la pluie. Signed and numbered 58.
1949-4-11-3165	67	L'Arc de Triomphe. Signed.
1949-4-11-3164	68	Coin de rue vue d'en haut. Signed and numbered 79.
1949-4-11-3157	74	Les boulevards. Signed.
1949-4-11-3171	79	Le bain. Second plate, first state, one of ten impressions in sanguine. Signed.
1949-4-11-5011 (6)	79	Le bain. Third state. In Frapier's album.
		The Album: *Maîtres et Petits Maîtres*
1949-4-11-5045 (4)	80	La coupe et le compotier. Third state. Signed.
1949-4-11-5045 (1)	81	Femme debout dans sa baignoire. Fourth state. Signed.
1949-4-11-5045 (2)	82	Paysage du midi. Fourth state. Signed.
1949-4-11-5045 (3)	83	La toilette assise. Third state. Signed.

Rodolphe Bresdin

	Van Gelder	
1920-5-12-43	84	La Comédie de la Mort. From the fifth printing.
1903-11-18-22	100	Le Bon Samaritain. From third or later printing.
1903-11-18-17	115	Baigneuses dans la montagne. Lithographic transfer, wrongly described by Van Gelder as an etching.
1903-11-18-18	122	Frontispiece. First state.
1903-11-18-19	124	Le Papillon et la Mare. Second state.
1903-11-18-16	130	Le Ruisseau des Gorges.
1921-6-22-1	138	Le Repos en Egypte. First state.
1903-11-18-21	151	La Pêche Miraculeuse.
1903-11-18-20	153	Le Gave. Probably from the posthumous edition.

Paul Cézanne

	Cherpin	
1949-4-11-3188	6	Les Baigneurs (petite planche).
1949-4-11-3189	7	Les Baigneurs (grande planche).
1939-10-11-5	8	Self-portrait.

Jules Chéret

	Maindron	
1948-1-24-1	55	Panneau decoratif. La Dance.
1929-6-11-75	189	Eldorado – Music Hall.
1913-7-22-5	207	Scaramouche: Pantomime-Ballet. A reduction of the poster. Inscribed: 'épreuve de passe'.
1929-6-11-74	292	Palais de Glace – Champs Elysées.
1913-7-22-4	427	Librairie Sagot: catalogue d'affiches illustrées.
1913-7-22-6	–	Proof of the cover for Maindron's book.
1901-6-11-121	–	Exposition de 1900: Weaving.
1901-6-11-122	–	Exposition de 1900: Lace-Making.

Camille Corot

	Delteil	
1914-10-12-141	30	Saules et peupliers blancs. Second state.
1949-4-11-3191	32	Le Fort détaché.
1915-4-8-33	33	La Lecture sous les arbres.
1913-12-13-14	34	Souvenir de Sologne.

Gustave Courbet

1920-5-12-41	–	L'Apôtre Jean Journet.

Edgar Degas

	Delteil	
1949-4-11-3194	53	Chanteuse de Café-Concert. First state.
1949-4-11-3192	57	Femme nue debout à sa toilette.
1925-3-44-53	60	Après le bain. Fifth state.
1949-4-11-3193	65	Femme nue debout à sa toilette. Second state.

Paul Gauguin

	Guérin	
1949-4-11-3265	2	Joies de Bretagne. From second edition.
1949-4-11-3266	10	Les Cigales et les Fourmis. From second edition.
1949-4-11-3268	50	Manao Tupapau. Signed and numbered.
1949-4-11-3267	51	Ia Orana Maria. On white wove.
1942-3-7-1	51	Ia Orana Maria. On simili – Japan.

Edouard Manet

	Guérin	
1949-4-11-3334	68	Le Ballon.
1949-4-11-3335	69	Lola de Valence. Falsified state with letters erased.
1949-4-11-3341	71	Le Gamin. Lettered state.

1949-4-11-3340	72	Les Courses. Before letters.
1949-4-11-3346	73	L'Execution de Maximilien. Before letters.
1913-8-14-55	73	L'Execution de Maximilien. Lettered state.
1949-4-11-3336	75	Guerre Civile. Lettered state.
1949-4-11-3337	76	La Barricade. Lettered state.
1949-4-11-3338	77	Berthe Morisot (in black). Lettered state.
1949-4-11-3339	78	Berthe Morisot (in outline). Lettered state.
1949-4-11-3342	79	Polichinelle. Third state, from the edition of twenty-five.
1949-4-11-3343	79	Polichinelle. Third state, from the unlimited edition.
1949-4-11-3345	82	Au Paradis. Lettered state.
1949-4-11-3344	84	Le Corbeau – premier essai.
1912-10-1-1 (1-4)	85–6	Le Corbeau. The book, lacking the ex-libris.
1949-4-11-3330 to 3333	86a-d	Le Corbeau. The four plates only, on China paper.

Jean François Millet

Delteil

1901-10-15-44	22	Le Semeur. Posthumous printing.
1957-6-20-2	22	Le Semeur. The cancelled stone.
1878-9-14-10	23	Portrait of Olivier de Serres. In Sensier's book.
1921-2-7-1	—	Potato Harvest. From the edition of 200 in 1920.

Camille Pissarro

Delteil

1949-4-11-3364	132	L'Oise à Pontoise.
1949-4-11-3365	140	Les Chemineaux. Inscribed: '1er état, no. 1'.
1920-10-18-6	142 II	Baigneuses à l'ombre. As published in 'L'Estampe Originale'.
1949-4-11-3366	147 I	Marché à Pontoise. Inscribed: '1er état, no. 1'.
1949-4-11-3367	147 III	Marché à Pontoise. Inscribed: 'Ep. def. no. 5'.
1920-10-18-4	148	Baigneuses au bord d'un étang.
1920-10-18-3	150	Baigneuse, le soir.
1925-5-11-3	152	Paysannes portant des fagots. Stamped and numbered 12/18.
1949-4-11-3368	155	Semeur. Inscribed: '1er état, no. 2'.
1949-4-11-3369	157	Femmes nues. Stamped and numbered 3/18.
1949-4-11-3370	158 I	Baigneuse près d'un bois. Inscribed: '1er ep. d'état, no. 1'.
1949-4-11-3371	158 IV	Baigneuse près d'un bois. Stamped and numbered 3/18.
1949-4-11-3372	159 I	Baigneuses luttant. Inscribed: 'Ep. d'état no. 2'.
1925-5-11-4	163	Faneuses d'Éragny. Stamped and numbered 10/12.
1949-4-11-3373	164	Bucheronnes. Inscribed: 'no. 3' on chine.
1949-4-11-3374	165	Groupe de paysannes. Inscribed: 'no. 4'.
1949-4-11-3375	166	Paysannes. Inscribed: 'no. 7 sur chine'.
1949-4-11-3376	169	Quai Boieldieu, à Rouen. Stamped and numbered 7/14.
1949-4-11-3377	170	Pont Corneille, à Rouen. Inscribed: '1er Etat, no. 2'.
1925-5-11-5	171	Le Pont Corneille. Stamped and numbered 14/18.
1925-5-11-6	172	Quai de Rouen. Stamped and numbered 6/12.
1949-4-11-3378	176 II	Rue Saint Romain. Inscribed: 'Ep. definitive no. 8'.
1925-5-11-7	179	Rue Saint Romain. Stamped and numbered 5/12.

1920-10-18-2	180	Gardeuse d'oies nue. Inscribed: 'No. 8 à chine'.
1920-10-18-5	181	Théorie de baigneuses. The inscription has been erased.
1949-4-11-3379	184	Rue Saint-Lazare, Paris. Inscribed: 'Ep. def. no. 25'.
1949-4-11-3380	185 II	Place du Havre, à Paris. Inscribed: 'Ep. def. no. 8'.
1949-4-11-3381	187	Gardeuse d'oies. Inscribed: 'No. 1' on white paper.
1949-4-11-3382	189	Groupe de paysans. Inscribed: 'Ep. def. no. 1'.
1949-4-11-3383	190	Vachère. Inscribed: 'No. 3'.
1923-12-14-4	192	Convalescence. Stamped and numbered 5/11.
1924-1-12-364	192	Convalescence. The original zinc plate.
1931-7-21-72	194 I	La Charrue. Inscribed: 'Ep. d'essai no. 1'.
1949-4-11-3384	194 III	La Charrue. With lithographed signature.

Puvis de Chavannes

1917-11-19-18	La Normandie. Signed and numbered 27.
1923-12-5-13	Head of a girl. Initialled and numbered 72.
1949-4-11-3190	Le Jeu (photolithograph). Initialled and numbered 16.
1913-6-17-9	Le Pauvre Pêcheur.

Odilon Redon

	Mellerio	
1949-4-11-5007 (1–10)	26–36	Dans le Rêve. Set of ten with frontispiece.
1949-4-11-3487	42	La souffle qui conduit les êtres. Signed.
1949-4-11-5006 (1–9)	44–52	Les Origines. Set of eight with frontispiece.
1888-6-19-158 to 163	54–59	Hommage à Goya. Set of six. From the first edition of fifty.
1949-4-11-3488	60	L'Oeuf, trial plate for Hommage à Goya. Undescribed first state.
1888-6-19-156	61	Profil de Lumière.
1888-6-19-164 to 169	62–67	La Nuit. Set of six.
1949-4-11-3489	68	Brunnhilde. Initialled by artist.
1949-4-11-3490	69	Cime Noire.
1888-6-19-157	70	Jeune Fiile.
1888-6-19-155	71	Christ. Signed.
1888-6-19-153	72	Araignée. Signed.
1949-4-11-3491	74	L'Idole.
1888-6-19-170 to 176	75–81	Le Juré. Set of seven published as an Album without text.
1888-6-19-151	82	Des Esseintes.
1949-4-11-3492 to 3502	83–93	Tentation de Saint-Antoine, first series, set of ten with cover (Plates 3 and 9 are before letter, the inscriptions being added in Redon's handwriting).
1905-11-1-3 to 9	94–100	A Gustav Flaubert (= Tentation de Saint-Antoine, Second series). Set of six with frontispiece.
1949-4-11-3503	94	Frontispiece. First state, inscribed and initialled by the artist.
1888-6-19-152	95	Plate 1, from the tirage à part, signed.
1949-4-11-3504	101	Les Débacles.
1888-6-19-154	102	Pégase Captif. First state, signed.
1949-4-11-3556	102	Pégase Captif. Second state.
1905-11-1-2	104	La Damnation de l'Artiste.

1949-4-11-3505	105	Les Chimères.
1949-4-11-3506	106	Les Flambeaux noirs.
1949-4-11-3557	107	Yeux clos. From first printing.
1949-4-11-3507	107	Yeux clos. From second printing.
1949-4-11-3508	108	Serpent-Auréole. Signed.
1949-4-11-3509	109	Sainte et Chardon. Signed.
1949-4-11-3511/3/4/6/7/3555	110–115	Songes. Set of six.
1949-4-11-3510	110	Plate 1. Before letters, initialled.
1949-4-11-3512	111	Plate 2. Before letters, initialled.
1949-4-11-3515	113	Plate 4. Before letters, initialled.
1949-4-11-3518	116	Parsifal. Impression dedicated to A. E. Tebb by the artist.
1949-4-11-3519	117	Druidesse. Initialled.
1949-4-11-3520	118	Entretien mystique.
1949-4-11-3521	119	Le Liseur. Impression from the cancelled stone.
1949-4-11-3522	120	L'Arbre. First state before letters. Signed.
1949-4-11-3559	120	L'Arbre. Second, published, state.
1905-11-1-1	121	Les Ténèbres.
1949-4-11-3558	122	L'Aile.
1949-4-11-3523	123	Lumière. Signed.
1949-4-11-3524	125	Mon Enfant.
1949-4-11-3525	126	Cellule Auriculaire. Undescribed first state before cutting down of the stone. Signed.
1949-4-11-3526	126	Cellule Auriculaire. Second state, published in L'Estampe Originale.
1949-4-11-3527	127	Cheval ailé.
1949-4-11-3528	128	Hantise. Second state.
1926-3-13-103	129	Le Coursier. Signed.
1949-4-11-3529	130	Brunnhilde. Signed.
1949-4-11-3530	131	L'Art Céleste. Signed.
1949-4-11-3531	132	Le Buddha. Second state before letters. Signed.
1949-4-11-3532	133	Centaur visant les nues. Before letters. Signed.
1949-4-11-3533	133	Centaur visant les nues. Lettered state. Signed.
1949-4-11-3534	134	La Tentation de Saint-Antoine, Third series. Frontispiece. From cancelled stone.
1949-4-11-3537	145	La Tentation de Saint-Antoine. Plate 12. Proof before letters. Signed.
1949-4-11-3535	151	La Tentation de Saint-Antoine. Plate 18. Before letters.
1973-5-12-5	156	La Tentation de Saint-Antoine. Plate 23. From later Vollard printing on 'Hollande'.
1949-4-11-3536	157	La Tentation de Saint-Antoine. Plate 24. Lettered state, but before the addition of Redon's name in top left corner.
1949-4-11-3546	158	Vieux Chevalier. Proof before letters. Initialled.
1949-4-11-3538	159	Frontispiece. Proof before monogram. Initialled.
1949-4-11-3539 to 3545	160–166	La Maison Hantée. Six plates with frontispiece.
1949-4-11-3548	167	La Sulamite. Proof, before letters, in yellow and black.
1949-4-11-3547	167	La Sulamite. Proof before letters in yellow and blue. Signed.
1949-4-11-3549	168	Beatrice. Proof before letters, printed in colours. Signed.
1949-4-11-3550	169	Tête d'enfant avec fleurs. Proof before letters in black. Signed.

1949-4-11-3552	170	Ari. Frist state. Printed in black on white paper. Initialled.
1949-4-11-3551	170	Ari. First state. Printed in red on white paper.
1949-4-11-3553	170	Ari. Second state.
1949-4-11-3554	172	Le Sommeil. No letters.
1949-4-11-3560 to 3575	173–185	Apocalypse de Saint-Jean. Twelve plates with frontispiece.
1949-4-11-3562	176	Apocalypse de Saint-Jean. Plate 3. Proof before letters.
1949-4-11-3564	177	Apocalypse de Saint-Jean. Plate 4. Proof before letters.
1949-4-11-3567	179	Apocalypse de Saint-Jean. Plate 6. Lettered state.
1949-4-11-3572	183	Apocalypse de Saint-Jean. Plate 10. Undescribed state before the stone was cut down at the top. Signed.
1949-4-11-3576	187	Planche d'essai II. Signed.
1949-4-11-3577	188	Planche d'essai III. Initialled.
1949-4-11-3578	190	Portrait of Edouard Vuillard. Signed.
1949-4-11-3579	191	Portrait of Pierre Bonnard. Signed.
1949-4-11-3580	192	Portrait of Paul Serusier. Initialled. Proof in red.
1949-4-11-3581	193	Portrait of Maurice Denis. Signed.
1949-4-11-3582	194	Portrait of Ricardo Vines. Signed.
1949-4-11-3583	195	Portrait of Juliette Dodu. Signed. In red.
1949-4-11-3584	196	Portrait of Roger Marx. In red.
1949-4-11-3585	197	Portrait of Llobet. Signed.

Auguste Renoir

Delteil

1927-7-12-12	30	Le Chapeau Épinglé. Second plate.
1949-4-11-3394	34	Portrait of Cézanne. On Japan paper.
1945-12-8-280	37	Portrait of Ambroise Vollard.

Alfred Sisley

Delteil

1949-4-11-3407	5	Bords du Loing, près Saint-Mammès.
1949-4-11-3408	6	Bord de Rivière, ou, Les Oies. Signed and numbered 11.

Henri de Toulouse-Lautrec

Delteil (The states are those of Adriani.)

1949-4-11-3610	14	Le Coiffeur. Second state. Signed.
1949-4-11-3611	16	La Loge au mascaron doré. Second state. Signed.
1920-5-22-42	18	Les vieilles histoires. Second state.
1949-4-11-3609	19	Pour toi. First state, numbered 72.
1930-2-22-1	25	Carnot malade! Third state.
1949-4-11-3612	26	Pauvre Pierreuse. First state on China paper. Signed.
1949-4-11-3613	28	Jane Avril. First state.
1924-10-10-1	28	Jane Avril. Second state as music title.
1949-4-11-3614	30	Paula Brébion.
1949-4-11-3615	32	Edmée Lescot.
1977-11-15-14	39	Miss Loie Fuller. Signed and inscribed 'passe'.
1949-4-11-3616	43	Mlle Lender et Baron.
1922-12-18-6	44	Répétition Générale.

1949-4-11-3617	47	Sarah Bernhardt. ? Trial proof on Japan.
1949-4-11-3618	52	Réjane et Galipaux.
1949-4-11-3619	61	Brandès et Le Bargy.
1949-4-11-3620	64	Carnaval. Third state.
1926-4-12-15	102	Mlle Marcelle Lender. Third state, in green, with 'Pan' blindstamp.
1922-7-8-29	102	Mlle Marcelle Lender. Fourth state, in colour, no. 37.
1938-10-8-107	104	Lender dansant.
1949-4-11-3621	107	Lender saluant. Numbered 12.
1949-4-11-3622	108	Lender et Auguez.
1949-4-11-3652	114	Mme Simon-Girard . . . dans 'La belle Hélène'.
1949-4-11-3623	117	Miss May Belfort saluant.
1949-4-11-3624	119	Miss May Belfort (grande planche). Third state. Signed and numbered 16.
1949-4-11-3625	124	Luce Myrès, de profil. Numbered 17.
1949-4-11-3626	125	Luce Myrès, de face.
1920-5-22-43/44	127	Cover for 'L'Estampe Originale'. Third state. Signed.
1922-12-18-7	143	La Valse des Lapins. First state. Signed.
1920-8-20-1 to 26	150–162	Portraits d'Acteurs et d'Actrices. One of the twenty double sets of the thirteen lithographs printed for the Société des Vingt.
1949-4-11-3627	153	Coquelin aîné. ? First edition.
1949-4-11-3628	163	Lender assise.
1949-4-11-3629	165	Miss Ida Heath. Signed.
1923-12-5-14	167	Souper à Londres. Signed.
1949-4-11-3630	170	Le Sommeil. Signed and numbered 9.
1949-4-11-3631	172	L'Entraineur.
1949-4-11-3632	175	Mary Hamilton. First edition.
1949-4-11-5010 (3)	175	Mary Hamilton. Frapier edition.
	179–189	Set entitled 'Elles': cover, frontispiece and ten plates.
1949-4-11-3634	179	Frontispice. First state, as cover. Inscribed: 'Série no. 72'.
1925-10-14-1	179	Frontispice. Second state, as frontispiece.
1949-4-11-3633	179	Frontispice. Third state, trial proof for the poster.
1949-4-11-3635	180	Clown. Second state.
1949-4-11-3637	181	Femme au plateau.
1949-4-11-3636	182	Femme couchée.
1949-4-11-3638	183	Femme au tub. Second state.
1949-4-11-3639	184	Femme qui se lave. Second state.
1949-4-11-3640	185	Femme à glace. Second state.
1949-4-11-3641	186	Femme qui se peigne. Second state.
1922-7-8-30	187	Femme au lit, profil. Fourth state.
1949-4-11-3642	188	Femme en corset. Second state.
1949-4-11-3643	189	Femme sur le dos. Second state.
1922-12-30-36	195	Oscar Wilde et Romain Coolus. Fourth state.
1949-4-11-3644	209	La petite loge. Signed and numbered 6.
1949-4-11-3645	216	Couverture pour 'Les Courtes Joies'. Frapier edition.
1914-3-24-5	219	Partie de Campagne. Third state, numbered 86.
1949-4-11-3647	224	Le vieux cheval.

1938-10-8-108	226	Au lit.
1949-4-11-3646	227	Polaire. Reprint of 1930.
1920-8-7-1 to 10	250–260	The set 'Yvette Guilbert': cover, frontispiece and eight plates.
1938-10-8-109	269	Chanteuse légère.
1949-4-11-3648	275	Au Star (Le Havre).
1949-4-11-3649	279	Le Jockey. First state, in black.
1949-4-11-3650	279	Le Jockey. Second state, in colours, on Japan.
1949-4-11-3651	283	Le cheval et le colley. First state. Signed.
1920-5-22-45	295	Les désastres de la guerre.
1930-2-22-2	334	Zamboula – Polka. Second state.
1921-6-14-18	339	Moulin-Rouge (La Goulue). Second state, lacking the top section.
1929-6-11-71	341	Divan Japonais.
1929-6-11-72	345	Jane Avril. Third state.
1929-6-11-73	346	Caudieux.
1926-10-7-1	354	May Belfort. Third state. Signed and numbered 15.
1922-12-18-8	365	Au Concert. Second state. Signed.
1914-3-24-6	366	La Passagère du 54. Second state. Signed and numbered 35.

Edouard Vuillard

	Roger-Marx	
1949-4-11-3593	2	La sieste ou la convalescence. Second state, initialled and numbered 60.
1945-12-8-303	13	La couturière. Third state.
1949-4-11-3594	28	Le Jardin des Tuileries. Second state. Signed.
1951-5-1-28	29	Jeux d'enfants. Third state. Signed.
	31–43	*Paysages et Intérieurs*. Album of twelve lithographs and cover.
1949-4-11-3595	31	Cover.
1949-4-11-3596	32	La partie des dames. Third state.
1925-3-14-60	33	L'avenue. Second state.
1951-5-1-27	34	À travers champs. Third state.
1949-4-11-3597	35	Intérieur à la suspension. Third state.
1949-4-11-3599	36	Intérieur aux tentures roses I. Fourth state.
1949-4-11-3598	37	Intérieur aux tentures roses II. Second state.
1949-4-11-3600	38	Interieur aux tentures roses III. Second state.
1949-4-11-3601	39	L'âtre. Second state.
1949-4-11-3602	40	Sur le pont de l'Europe. Second state.
1949-4-11-3603	41	La Pâtisserie.
1949-4-11-3604	42	La Cuisinière. Second state.
1949-4-11-3605	43	Les deux belles-soeurs. Third state.
1949-4-11-3607	44	La naissance d'Annette. Undescribed trial state in four colours, before addition of the blue and red.
1938-11-30-4	45	Le jardin devant l'atelier. Second state. Signed.
1949-4-11-3606	47	Projected cover for Vollard's unpublished third *Album d'Estampes Originales*. Second state.
1949-4-11-3608	48	Une galerie au Théâtre du Gymnase. Third state.
1941-3-27-10 (1, 2, 9, 12, 16, 18)	54-59	The six plates in H. J. Laroche: *Cuisine*, Paris, 1935.